Enzo Carli

# SIENESE PAINTING

Scala Books

distributed by Harper & Row, Publishers

# Contents

All paintings reproduced are in Siena unless otherwise stated.

Front cover: Ambrogio Lorenzetti, *Allegory of Good Government*, detail, Peace.
Back cover: Memmo di Filippuccio, a scene from the cycle of frescoes in the Palazzo del Popolo in San Gimignano, and *Surrender of a Castle* in the Palazzo Pubblico in Siena.

First published in the U.S.A. and Canada in 1983 by
Scala Books
342 Madison Ave., New York, N.Y. 10017
ISBN 0-935748-25-3

First published in the U.K. in 1983 by
Frederick Muller Limited
Dataday House, 8 Alexandra Road, Wimbledon
London SW 19 7JU
ISBN 0584 50002 5

© Copyright 1982 Scala, Istituto Fotografico Editoriale, Firenze
Translated by Patrick Creagh
Photographs: Scala (A. Corsini, M. Falsini, M. Sarri) except
nos. 38 (Walker Art Gallery, Liverpool), 81 (Giraudon, Paris)
and 83 (National Gallery, London).
Printed and bound in Italy by Officine Grafiche Firenze 1982

# From the Origins to Duccio

The earliest evidence of painting in the territory of Siena dates back to the end of the 12th or beginning of the 13th century, and consists of three Crucifixes. Perhaps the oldest is the one in the Pinacoteca, which originally came from the church of San Pietro in Villore at San Giovanni d'Asso, while another (also in the Pinacoteca) came from the church of Santa Chiara in Siena, and certainly dates from the very beginning of the 13th century. The third is in the Museum of Montalcino. All three give us the living Christ, presented according to the Romanesque taste of the time as the one who triumphed over death, rather than the divine Victim, and seem to be influenced by a well-known Crucifix in the Cathedral of Spoleto, signed by Alberto Sotio and dated 1187. The light colouring, with a preference for pale blues, also connects these works with the tradition of Umbria, and of Spoleto in particular. But the oldest work of Sienese painting that can be exactly dated is an altar-frontal in tempera from the Badia Berardenga (no. 1 in the Pinacoteca of Siena), which bears the date 1215 at the top of the frame. It shows the *Redeemer in the Act of Blessing Flanked by Two Angels* within an "almond" of stars which is itself surrounded by the symbols of the Evangelists. At the sides are six scenes concerning the wood of the True Cross and its discovery by St. Helen.

Here too the colouring is light toned on a gold background, with touches of sky blue. But the outstanding feature of this painting, executed with considerable elegance and precision, particularly as regards the symbols of the Evangelists, is that some parts of it are done in subtle relief, while also in relief are the richly decorated broad bands dividing up the various compartments. The result is that it might almost be taken for goldsmith's work, rather like a metal and enamel cover of an illuminated manuscript.

Also in light relief is the *Madonna and Child* in the Cathedral Museum (Museo dell'Opera del Duomo), incorrectly called the "Madonna with the Large Eyes," a feature which has given rise to the opinion that it is by the same author as the altar-frontal mentioned above (no. 1 in the Pinacoteca). And although this is not certain, the fact remains that the stylistic trends are the same, especially as the Madonna was originally flanked by small panels depicting episodes from her life that were later removed.

This Madonna is famous because it was before this very painting, when it was in the Cathedral, that the Sienese dedicated their city to the Virgin on the eve of the battle of Monteaperti (September 4th, 1260), and its nickname refers not to the eyes of the Madonna in the painting, but to the eye-shaped silver *ex-votos* with which she was surrounded after the great victory against the Florentines. The author of this painting was certainly responsible for two others of the same kind, the *Madonna* in the Pieve of Tressa, just outside Siena, and the one in the Chigi Saracini Collection in Siena. It has thus been possible to make a partial reconstruction of the career of one Sienese painter, known as the **"Maestro di Tressa,"** which demonstrates that the Romanesque taste predominated in the earliest Sienese painting.

The first Sienese painter for whom we have a name, as well as a number of paintings, is on the other hand entirely Byzantine in style. This is **Guido da Siena**, who signed the vast painting known as "La Maestà," formerly in the church of San Domenico and now in the Palazzo Pubblico. It bears the date of 1221. A number of theories

have been put forward concerning this date: it may be due to a mistake on the part of whoever repainted the inscription, or it may refer to an older picture replaced by this one in the church of San Domenico. The fact is that this date is now unanimously rejected by scholars since it clashes with the style of the work, which very obviously belongs to the last third of the 13th century. It should be said, however, that the flesh tones of the Virgin and Child were retouched in the first two decades of the 14th century by an excellent follower of Duccio di Boninsegna, if not by Duccio himself.

This work of Guido's, surmounted by a triangular cusp containing the *Redeemer in the Act of Blessing Flanked by Two Angels*, is evidence of a fully mature Byzantine tendency (what Vasari defines as the "Greek manner") of which there is no trace in the Tuscan painting of the first half of the 13th century, and among other things the image of the Madonna and Child is framed above by a triple arcade undoubtedly inspired by those of the pulpit made for Siena Cathedral by Nicola Pisano and his assistants between 1265 and 1268. This confirms the likelihood of a later date, and critics tend to place it at around 1280. It was originally flanked by opening panels, called "aliae" or wings, painted with *Stories of the Life and Passion of Christ*, of which twelve have been identified (five in the Pinacoteca of Siena, nos. 9-13, three in the Altenburg Museum, two in the Louvre, one in the Episcopal Museum of Utrecht, and one in the Princeton Museum). All these panels were painted by Guido himself and one assistant.

A number of works have been attributed to Guido da Siena and his immediate circle. Those which have been most largely endorsed by critical opinion inlcude an altar-frontal from Colle Val d'Elsa, now in the Pinacoteca (no.7), with the *Madonna and Child* flanked by four *Saints*, although originally there must have been six. When the outer two were removed we also lost part of the inscription, which seems identical with that of the painting in the Palazzo Pubblico. The beginning must have contained the name of the artist, while the date, the only part that survives, is 1270. It is probable, however, that this is the work of a pupil or immediate follower, while a lost inscription recorded in a document gave the date of 1262 for another great *Madonna and Child* in the Pinacoteca (no. 16), known as the "Madonna of San Bernardino" after the church where it came from. This Madonna is not universally recognized as being by Guido, perhaps it is the work of a master who shared his identical artistic background.

Some scholars think that Guido's first work was the fine altar-frontal painted on linen (no. 8 in the Pinacoteca). Originally in the church of Santa Cecilia at Crevole. It depicts the *Transfiguration*, the *Entry into Jerusalem*, and the *Raising of Lazarus*. It was probably used to replace or cover the altarpiece during Lent. It is a most refined piece of work, in the Byzantine stylization of the architectural features and the landscape, in the delicacy of the colours, and in the composition of the scenes, the narrative effectiveness of which gives us a foretaste of Duccio himself.

Characterized by an almost "folk" immediacy of impact are the episodes on the two diptychs (nos. 4 and 5 in the Pinacoteca), one of which – dealing with the life of the Blessed Andrea Gallerani – may be the work of the painter who assisted Guido on the "aliae" of the Maestà, while the other (no. 4), containing episodes from the lives of

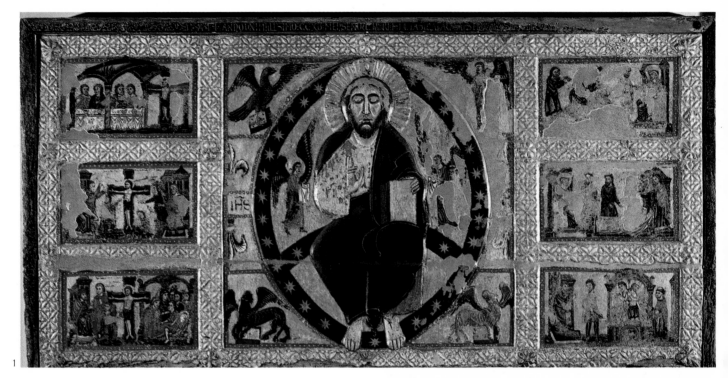

St. Francis, St. Clare, St. Bartholomew and St. Catherine of Alexandria, has been attributed to Guido himself. Their colouring is in general extremely lively, and as an example of their narrative strength we need only cite the scene in which St. Clare drives back a Saracen attack on the convent.

But the most choice product of this particular artistic current – which we might call "Guidesque," since Guido is the only one whose name we know – is the altar-frontal bearing the number 15 in the Siena Pinacoteca. It comes from the church of San Pietro in Banchi (now destroyed) and shows *St. Peter Enthroned,* flanked by six scenes: the *Annunciation,* the *Nativity,* the *Calling of Peter and Andrew,* the *Freeing of St. Peter from Prison,* the *Fall of Simon Magus* and the *Crucifixion of St. Peter.* A very seductive hypothesis views this undoubted masterpiece as the zenith of Guido's career. And indeed his artistic culture is a very complex one, for in some of Guido's works we not only find echoes of the Florentine artist Coppo di Marcovaldo (who was taken prisoner at the battle of Monteaperti and in 1261 painted the "Madonna del Bordone" in exchange for his freedom), but here we see that he also knew the work of Cimabue, evident above all in the figure of St. Peter and in the episode of the calling of the Apostle. But unlike what we find in the painting of the great Florentine, the chromatic range of this frontal is confined to delicate tones of pink, light green and pale blue, while there is a feeling of gentle and tender involvement in the events depicted. For example, St. Peter is shown as taking a few first hesitant steps as the angel leads him by the hand out of the darkness of his prison, while the Madonna most touchingly withdraws when faced with the sudden appearance of the angel of the Annunciation.

Quite different in style is another admirable altar-frontal (no. 14 in the Pinacoteca). Coming from the ex-convent of Santa Petronilla, it shows *St. John the Baptist Enthroned* flanked by twelve episodes from his life. If it were not for certain inscriptions in Latin characters, one might suppose that this work was produced in some centre of Byzantine culture, so evident are the "Greek" features of the solemn figure of the Baptist and the whole manner of working in the scenes at the sides, abounding in typically Oriental architectural elements, figures that are subtly and elegantly stylized in a kind of taste that has even been defined as "Islamic," and colours that are extremely lively and as dense as enamel or glazing, strong in contrasts and composed almost heraldically. It is most probably the work of a "Latinized" eastern painter who worked in Central Italy, because his hand has also been recognized in a painting of *St. Francis and Stories of his Life* in the Museum at Orte.

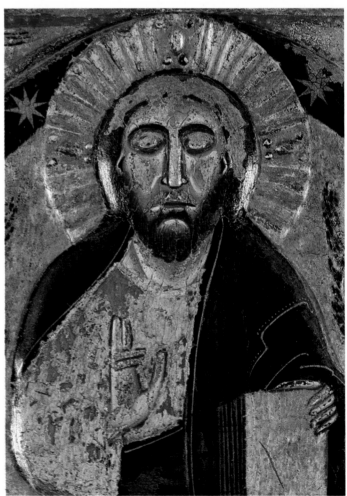

**13th-century Sienese Master**
1. *Redeemer in the Act of Blessing Flanked by Two Angels.* Pinacote a.
2. *Redeemer in the Act of Blessing Flanked by Two Angels, detail.*

**Maestro di Tressa**
3. *Madonna and Child, "Madonna with the Large Eyes."* Cath
Museum.

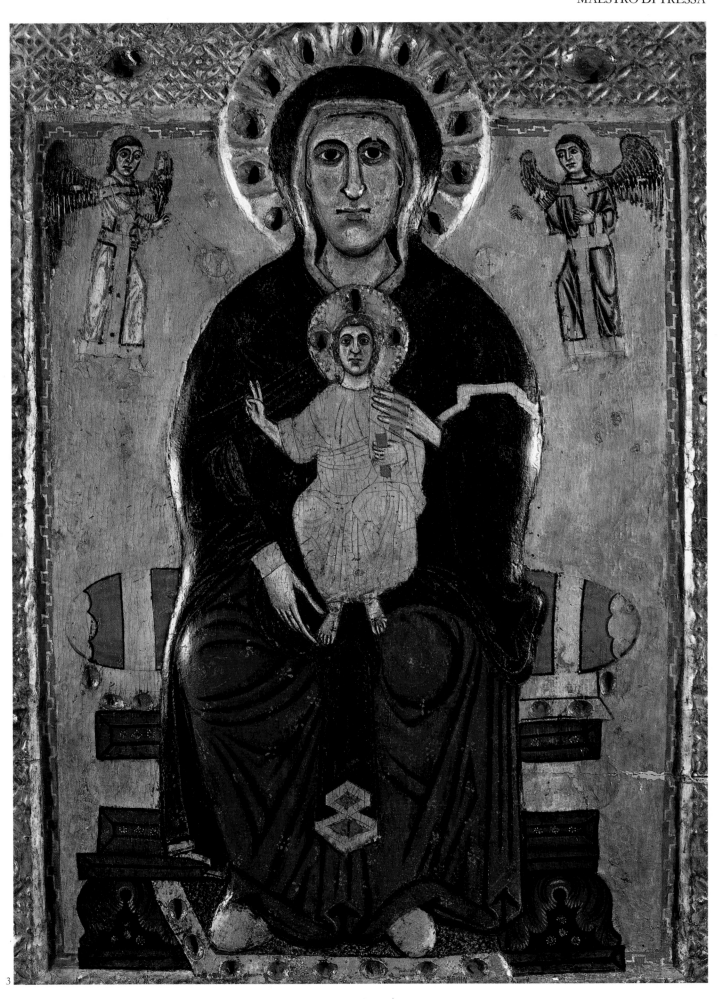

3

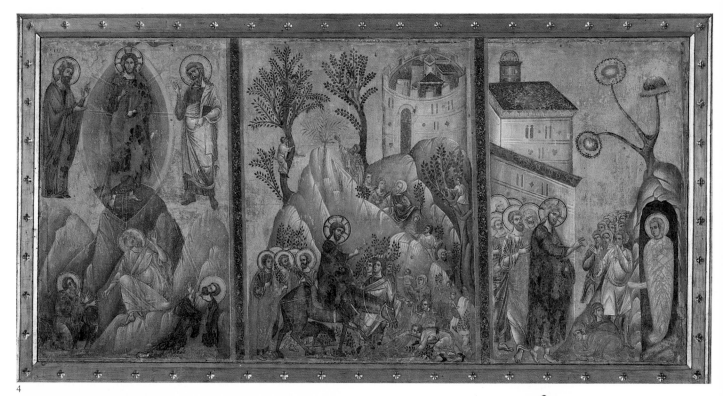

4

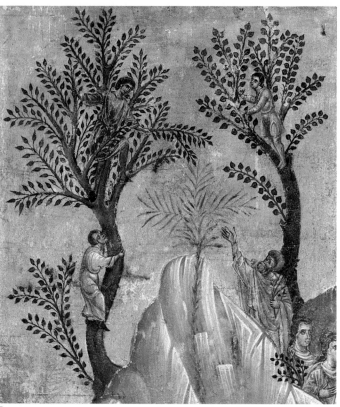

5

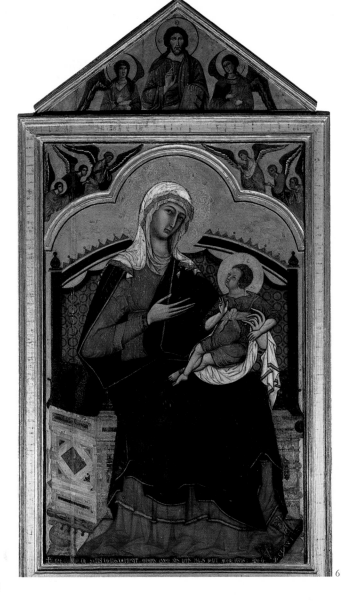

6

**Guido da Siena**
4. *Transfiguration, Entry into Jerusalem and Raising of Lazarus.*
   Pinacoteca.
5. *Entry into Jerusalem, detail.*
6. *Maestà.* Palazzo Pubblico.
7. *St. Clare Drives Back a Saracen Attack.* Pinacoteca.

7

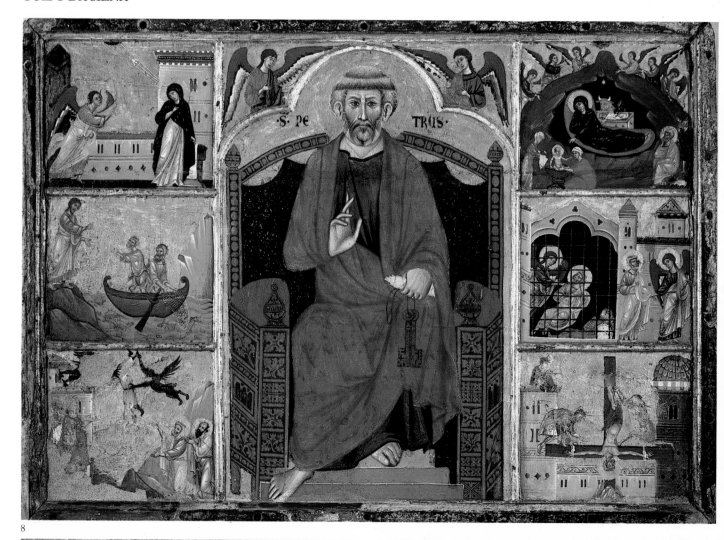

8

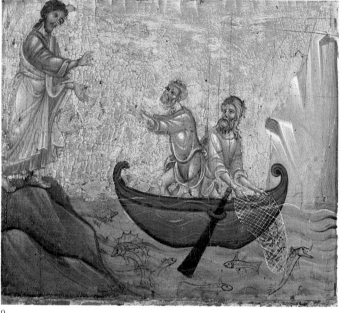

9

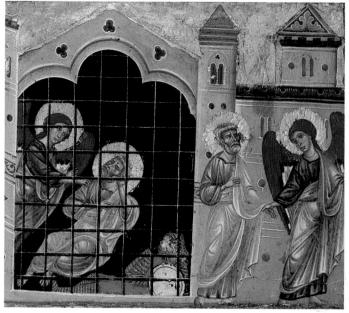

10

**Guido da Siena**

8. *St. Peter Enthroned.* Pinacoteca.
9. *St. Peter Enthroned, detail, The Calling of Peter and Andrew.*
10. *St. Peter Enthroned, detail, The Freeing of St. Peter from Prison.*

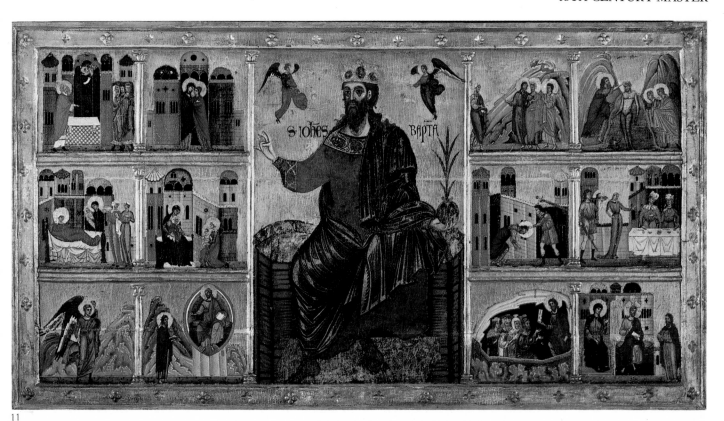

11

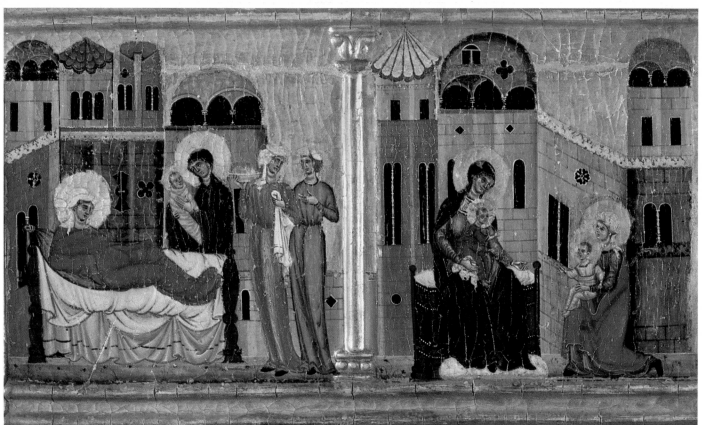

12

**13th-century Master**
11. *St. John the Baptist Enthroned.* Pinacoteca.
12. *St. John the Baptist Enthroned, detail, Birth of John the Baptist and the Meeting of Jesus and John the Baptist.*

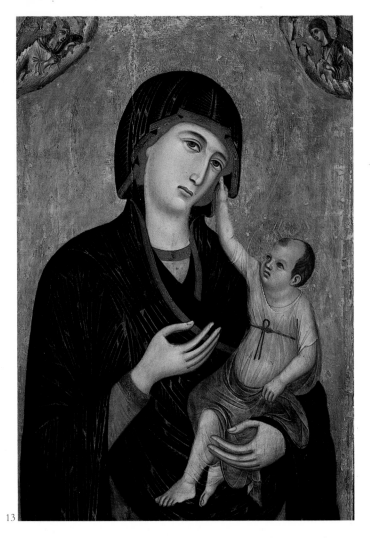

13

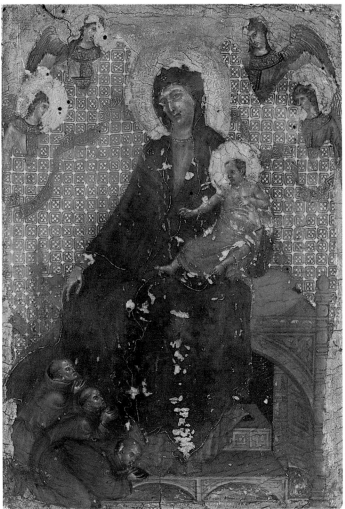

14

The two altar-frontals numbered 14 and 15 are exactly contemporary with the earliest work of **Duccio di Boninsegna**, the first mention of whom dates from 1278, when he was paid for painting twelve chests containing documents of the Commune of Siena. However, the modest scope of this piece of work, a job more for a craftsman than for an artist, should not lead us to think that he was then a mere beginner, or that his beginnings were necessarily on this humble level, because even when he was already famous he went on doing things of this kind, such as the decoration of the covers of the registers of the "Biccherna," the account books of the Commune. And in view of the fact that in 1285 Duccio got a really important commission for a large painting for the church of Santa Maria Novella in Florence, critics have long been debating on his previous activities and artistic education. A recent current of thought holds that he was at one time the pupil of the great Cimabue, and that he collaborated with this master on the frescoes in Assisi.

It is beyond doubt that there was some degree of contact between Duccio and the Florentine master, but we do not have to think in terms of a master-pupil relationship, seeing that the painting scene in Siena during the latter half of the 13th century was, as we have seen, very much alive and open to numerous cultural trends, including that of Florence, while the work which critics are unanimous in attributing to Duccio before the date of 1285 – not necessarily his first work, but at any rate the first definitely credited to him – has very little relation of any kind with the art of Cimabue. This painting is the *Madonna di Crevole*, from the church of Santa Cecilia at Crevole, now in the Cathedral Museum. Before we begin to speculate about who could have been Duccio's teacher, we should point out the completely fresh manner in which Duccio has interpreted the Byzantine motif of the Madonna's gesture of pointing with the index finger of her right hand at the Child cradled in her left arm. The face

of the Virgin, with the most tender expression, is gently looking down, while the infant Jesus reaches up to grasp his mother's veil; the outlines are all softened, as far as could be from the harshly incisive outlines of the school of Guido, and the flesh has almost the transparency of alabaster.

As we said above, in 1285 Duccio got a commission from the Compagnia dei Laudesi of Santa Maria Novella in Florence to paint a "*magna tabula . . . de pulcerima pictura.*" This is the so-called *Rucellai Madonna*, now in the Uffizi, and which from Vasari on, until the document recording the commission was published, was unanimously held to be a masterpiece of Cimabue. And indeed there are features reminiscent of Cimabue, especially in the grave and solemn figure of the Christ child raising his arm in blessing. But instead of the firm and compact structure typical of Cimabue, Duccio gives us a light and spacious composition, in which for example the Angels, instead of clustering around the throne of the Madonna, as in the almost contemporary *Madonna of Santa Trinita* in the Uffizi, and in the fresco in the Lower Basilica at Assisi – both the work of Cimabue – appear almost to hover in mid-air. Meanwhile the flowing lines of the drawing, especially noticeable in the profile of the Madonna, are accentuated by the whirling lines of the hem of her cloak, in tune with a taste already current in the Gothic period, and quite foreign to Cimabue's idiom.

But strong reminiscences of Cimabue are to be found in the great round window of the Choir in the Cathedral of Siena, made in 1288 on the basis of drawings by Duccio, and indeed to such an extent that some parts of it are now attributed to the Florentine master.

Numerous documents bear witness to the fact that Duccio was nearly always working in Siena. One of these refers to a Maestà with a predella, painted in 1302 for the chapel of the Palazzo Pubblico.

There is no longer any trace of this important painting, but as evidence of the fact that Duccio was constantly at work during the long period that led up to the great achievement of the Maestà for the Cathedral we have a number of paintings now universally attributed to him. One of these, and the most famous, is the *Madonna of the Franciscans* in the Pincoteca of Siena (no. 20), a painting of truly minuscule proportions (23.5x16.9 cm.), but conceived with monumental breadth and sweep as regards the pictorial image of the Virgin's cloak, which billows out so far as to cover the figures of the three kneeling friars. The result is that the spaces seem to radiate outwards, while the Gothic taste implicit in the painting is seen in the almost musical unravelling of the lines and the out-of-proportion background, undoubtedly influenced by French miniatures. This work may be dated at between 1290 and 1300, and contemporary with it or only a little later are the Madonna formerly in the Stoclet Collection in Brussels, a triptych in the National Gallery in London, a Madonna in the Gallery in Perugia, and a polyptych in the Pinacoteca of Siena (no. 28). This last painting may also contain the work of an assistant.

On October 9th, 1308 the *Operaio* (administrator) of the Cathedral of Siena, Messer Jacopo del fu Giliberto de' Marescotti, commissioned Duccio to do the altarpiece for the High Altar. The artist worked on this altarpiece, the Maestà, for thirty-two months, and on June 9th, 1311 the people of Siena, led by the clergy and the civil authorities, went to his studio to fetch it. Having carried it round the Piazza del Campo they bore it in solemn procession to the Cathedral, and this was a memorable event in which the entire city expressed not only its devotion to the Virgin, but also its admiration for a masterpiece that came even then, freshly, from the hands of its creator.

The Maestà consists of a large number of panels painted on both sides. The centrepiece is a grandiose composition showing the *Madonna Enthroned and Child* surrounded by *St. Catherine of Alexandria, St. Paul, St. John the Baptist, St. Peter, St. Agnes* and twenty *Angels*, while kneeling in the foreground are the four Patron Saints of Siena, *Ansano, Savino, Crescenzio* and *Vittore*. Above, under a series of arches, are the busts of ten *Apostles*. On the step of the throne is the inscription: MATER SANCTA DEI - SIS CAUSA SENIS REQUIEI - SIS DUCIO VITA - TE QUIA PINXIT ITA ("Holy Mother of God, bring peace to Siena, and life to Duccio, because he painted you like this"). The inscription seems not only to express the "civic" meaning of the painting, by invoking the Madonna to intercede for peace for the city, but also to suggest that the artist himself was aware that he had made a masterpiece that deserved the Virgin's special protection.

Under the main scene was the predella, with seven panels divided by figures of the Prophets, and showing scenes of the Life of Christ from the *Annunciation* to the *Disputation in the Temple*. The narrative continued on the back of the predella, with nine scenes (one of which has been lost) representing episodes and miracles in the Life of Christ, whose Passion, from the *Entry into Jerusalem* to the *Appearance at Emaus*, occupies the entire back of the main composition, divided into twenty-six compartments, while a series of detached panels show scenes from the life of Christ after the Resurrection and from the life of the Virgin after the death of Christ.

In 1505 the altarpiece was removed from the High Altar, while in 1771 the main composition was detached from the scenes at the back, which led to the dispersal of a number of episodes (eight of which are now in museums and collections abroad), the loss of the first panel on the back of the predella, and probably also that of the four main episodes from the top of the frame, of which no trace has been found. What remains, consisting of the main scene with the Madonna and Child, the panels behind it, seven episodes from the predella and twelve from the top of the frame, are now preserved in the Cathedral Museum.

The concept of the Madonna as the Queen of Heaven surrounded by a court of Angels and Saints has certain literary precedents, but in the pictorial arts it may be said to be a purely Sienese invention; and the Maestà of Duccio is its prototype. The composition is organized in a rigorously symmetrical manner on either side of the great marble throne, the sides of which open forwards like doors, while the figures also resemble architectural features, with an immobility that matches the uniformity, or at any rate the constancy, of their stylized features, which is evident above all in the twenty beautiful Angels, and this infuses the whole composition with a profound spirituality. We are made to feel the beatifying ecstasy of each one of them as he contemplates the Madonna and is aware of the part he plays in this heavenly gathering. The image of the Madonna dominates the whole, partly because she is so much bigger than the other figures, and partly on account of the breadth of space surrounding her imposing bulk, softened by the flowing Gothic rhythms of the deep blue cloak against the gold-embroidered cloth hanging from the back of the throne. Her regal dignity is made human by the gentle bowing of the head and the sweet though penetrating look in her downcast eyes, as if she were piously welcoming the prayers of the faithful kneeling at her feet. The art of Duccio is exceptional, and one might even say miraculous, for the way it combines the new Gothic spirit of the West with the Byzantine tradition traced back to its remotest Hellenistic origins, hence the very ancient "Greek" feeling in those twenty Angels. And of this art the Maestà is the most profound and original example.

**Duccio di Boninsegna**
13. *Madonna di Crevole*. Cathedral Museum.
14. *Madonna of the Franciscans*. Pinacoteca.
15. *Rucellai Madonna*. Florence, Uffizi.

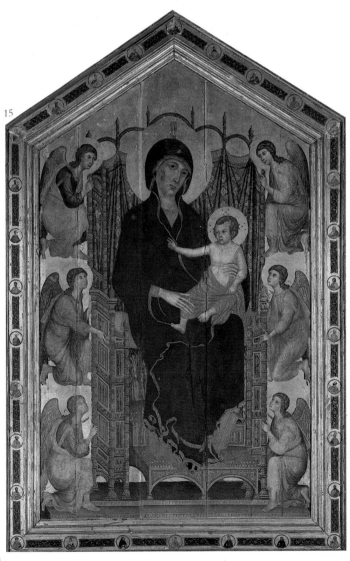

15

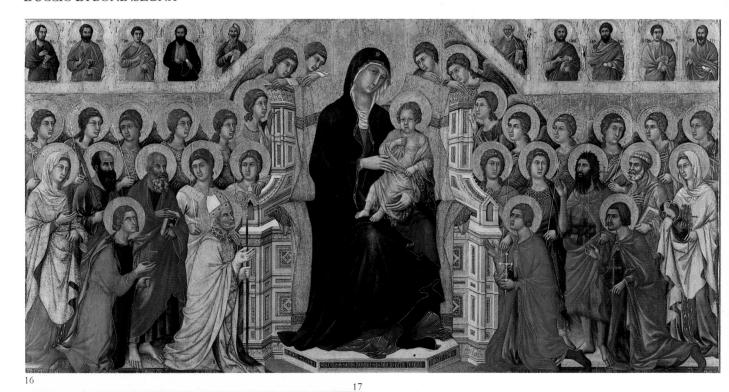

16                      17

Nor does Duccio's art in any way fall short in the fifty-three episodes surviving from the predella, and the back and top of the Maestà itself. For the most part these reflect Byzantine models of the kind that became known through the spread of illuminated manuscripts which had already been incorporated into the Sienese painting of the second half of 13th century. As examples of this we could refer back to the wings of Guido da Siena's Maestà and those of the altar-frontal of *St. Peter Enthroned*. But the conventional aspects of them are raised to a different plane by a fresh and more direct approach to their original narrative content, to the essence and significance that the artist perceives in the various episodes from the Gospels, and finally the extraordinary enrichment brought about by secondary features such as buildings and landscapes, that are inserted perfectly harmoniously into the compositions in general, and infused with the same spiritual cast of mind with which Duccio invested his human figures.

The astonishing variety of compositional solutions found here have led some critics to suppose that all the outstanding Sienese masters of the time, Simone Martini, the Lorenzetti brothers, Ugolino and Segna di Bonaventura, also worked on it. But in fact, given the delicately lyrical and evocative tone of each episode, eloquent even in the perfect rhythmical play of figures and spaces, the narrative cycles do have considerable unity of conception, though in particular instances they anticipate the essential features of various motifs and ideas that were later taken up and reworked in different contexts by the Sienese painters of subsequent years.

**Duccio di Boninsegna**
16. *Maestà.* Cathedral Museum.
17. *Maestà, detail, St. Agnes.*
18. *Maestà, detail, an angel.*

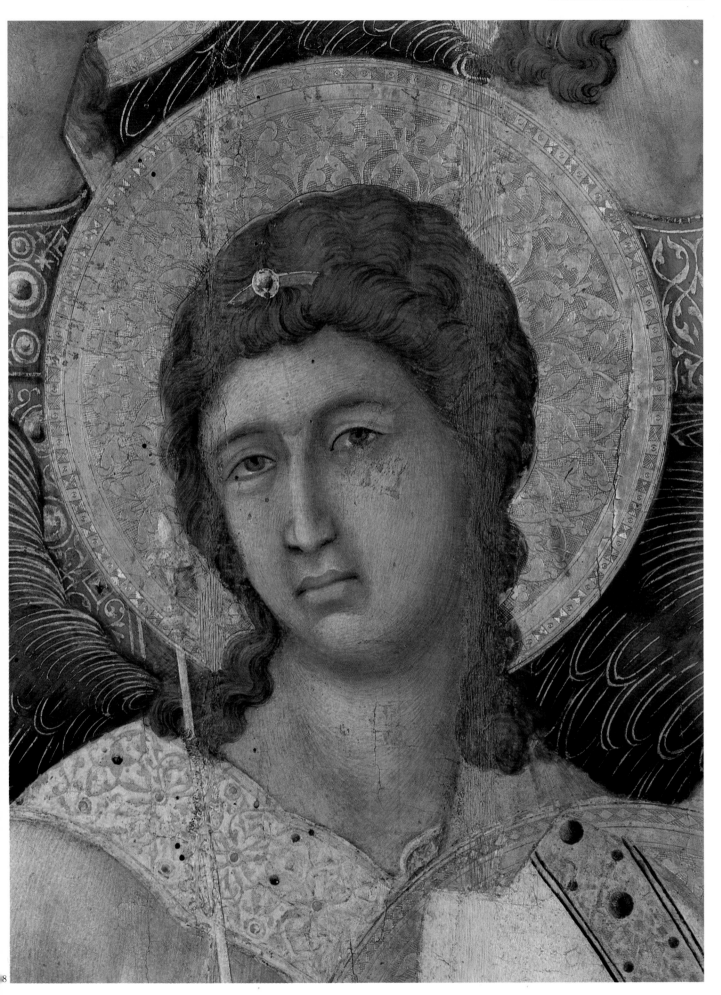

8

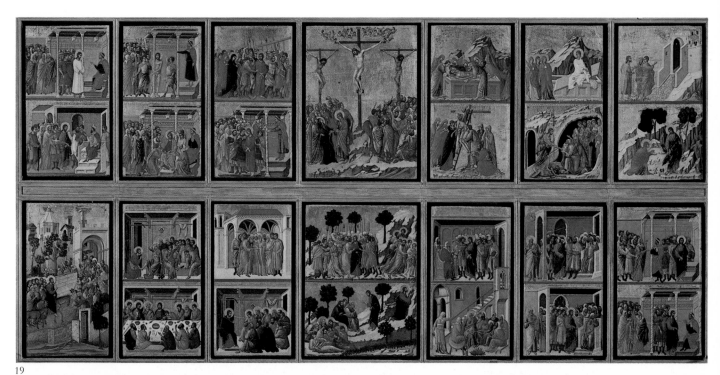

19

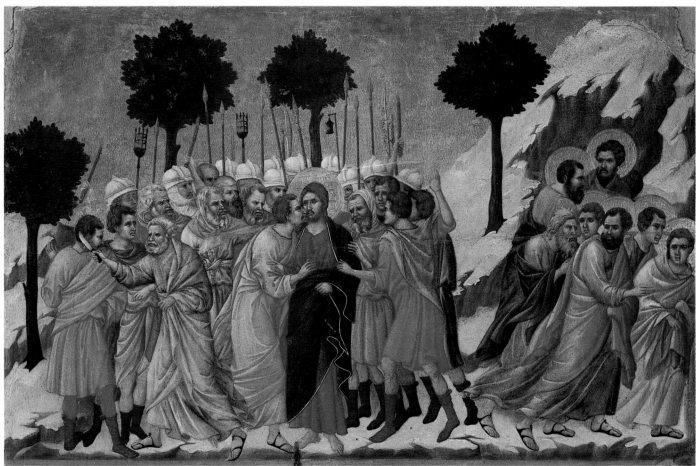

20

**Duccio di Boninsegna**
19. *Maestà, verso.* Cathedral Museum.
20. *Maestà, detail, The Kiss of Judas.*
21. *Maestà, detail, Christ before Annas and the Betrayal of Peter.*

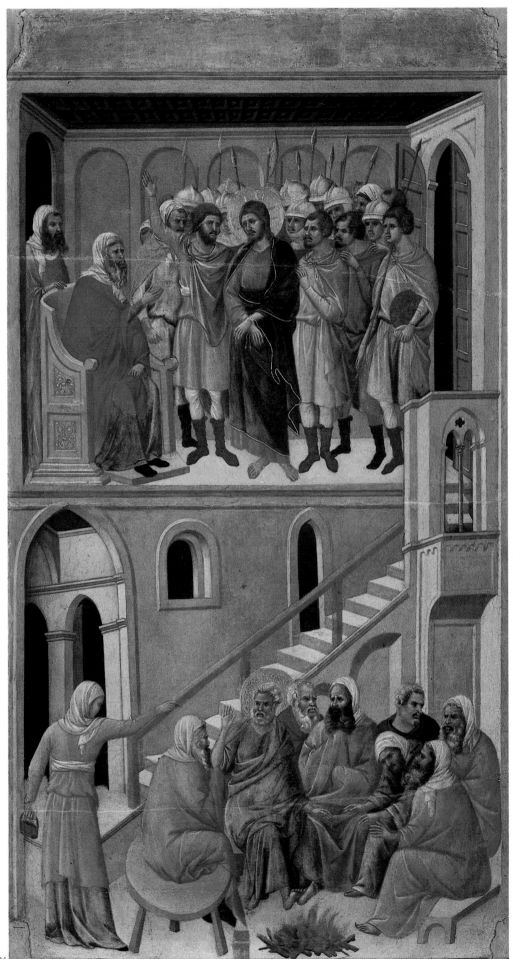

21

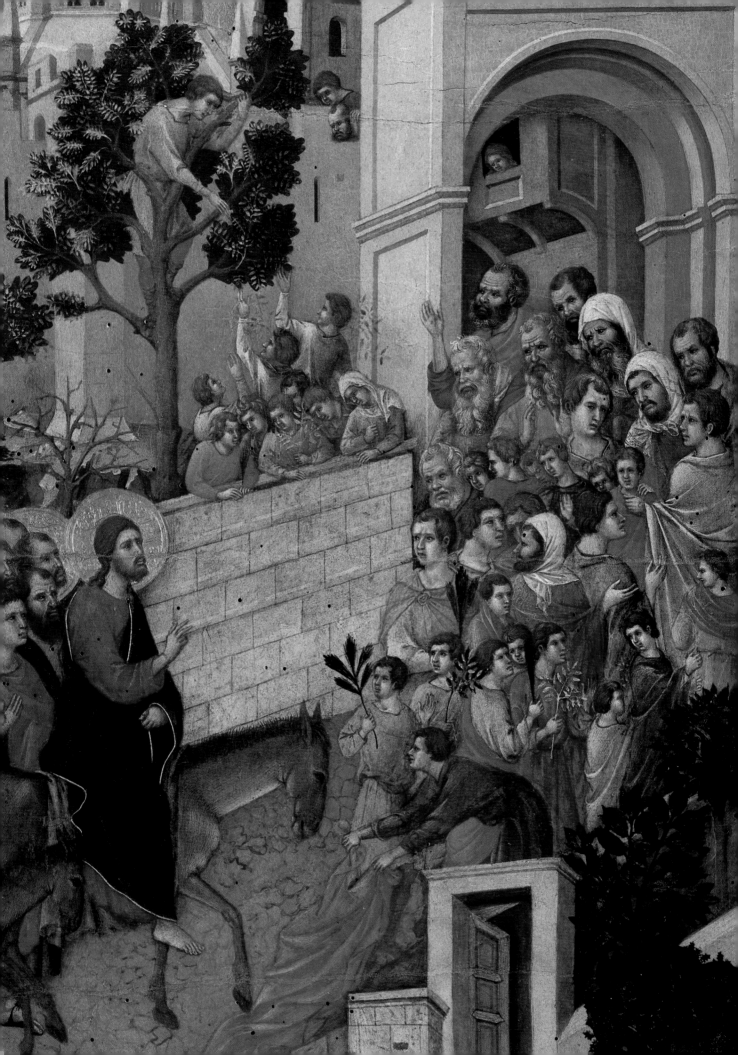

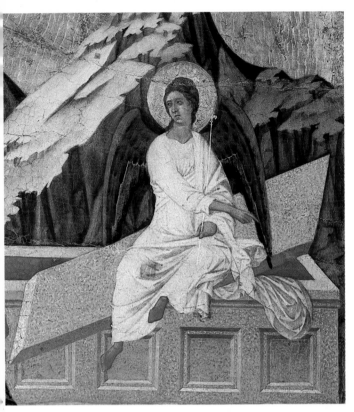
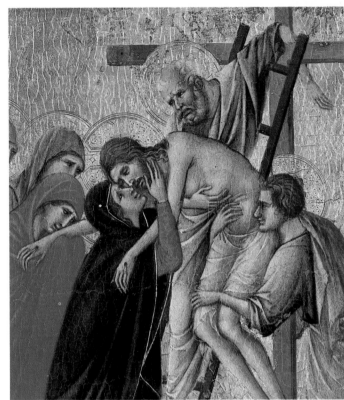

**Duccio di Boninsegna**
22. *Maestà, detail, Entry into Jerusalem.*
23. *Maestà, detail, The Marys at the Sepulchre, detail, the angel.*
24. *Maestà, detail, Deposition.*

Duccio died some time between the end of 1318 and October 16th 1319, and we know nothing of what he may have painted after the great Maestà. Attributed to his last period are the polyptych (no. 47) and the Madonna (no. 583) in the Pinacoteca of Siena, though in the first the hand of at least one assistant has been traced, while the attribution of the second is by no means universally accepted. All the same, a numerous though select band of disciples and followers had formed around him even before he began work on the Maestà. One of the first was the **"Maestro di Badia a Isola,"** so called after a painting in the church of that name near Monteriggioni, but the best known was **Ugolino di Nerio**, mentioned in documents between 1317 and 1327. Also mentioned by Vasari, it was he who painted the first polyptych for the High Altar of the church of Santa Croce in Florence; this was dismantled at the beginning of the last century, and the panels are now distributed among a number of museums, all of them abroad. On the basis of these panels critics have credited him with a large number of altarpieces and paintings, which show him as the most subtle of Duccio's followers, capable at times of achieving delicate but intensely dramatic effects, as for example in the *Crucifixion with St. Francis* (no. 34 in the Pinacoteca of Siena).

A slightly academic version of Duccio's manner is represented by a painting, noble enough in its way, by **Segna di Bonaventura** (documented from 1298 to 1327), a nephew of Duccio's and the author of four signed works, while others have been attributed to him on stylistic grounds. The most important of the signed works is a *Madonna with St. Gregory, St. John the Baptist, Four Angels and Four Donors*

in the Collegiate Church at Castiglion Fiorentino, that may conceivably reflect the style of Duccio's lost Maestà, painted in 1302 for the Palazzo Pubblico in Siena. It is outstanding for the icon-like solemnity of it, the incisiveness of the drawing, and an intense degree of chiaroscuro that however does nothing to dim the dazzling liveliness of the colours.

The signature SEGNA ME FECIT is found also on the sword of a *St. Paul* in a fragmentary polyptych (no. 40 in the Pinacoteca of Siena). The other works signed by him are a triptych in the New York Metropolitan Museum and a *Crucifix* in the Historical Museum in Moscow.

The son of Segna di Bonaventura was **Niccolò di Segna** (documented from 1331 to 1345), who lent added strength to his father's style, and whose masterpiece is the glowing *Madonna della Misericordia* (Madonna of Mercy) formerly in the church of Vertine in Chianti. Now in the Pinacoteca of Siena (unnumbered), it was probably painted in 1331-1332. After this, though with some inspired moments, such as in the *Saints* and *Prophets* done for the sacristy cupboard in the Basilica of San Lucchese in Poggibonsi, his manner tended increasingly towards cruder forms, as in the *Crucifix* (no. 45 in the Pinacoteca) signed and dated 1345, which is one of the last examples of the tradition of Duccio, and is not without the influence of Pietro Lorenzetti.

The example of Segna di Bonaventura was probably followed also by the gentle **Meo di Guido**, who in 1315 became a citizen of Perugia. There is no trace of his activity in Siena, but his work was

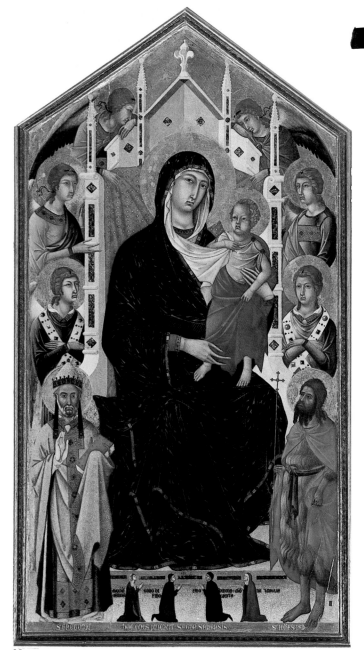

25

### Segna di Bonaventura
25. *Madonna with Saints and Angels*. Castiglion Fiorentino, Collegiate Church.

### Niccolò di Segna
26. *Madonna della Misericordia*. Pinacoteca.

### Ugolino di Nerio
27. *Crucifixion with St. Francis*. Pinacoteca.

### Memmo di Filippuccio
28. *The Bedroom*. San Gimignano, Palazzo del Popolo.
29. *The Bath*. San Gimignano, Palazzo del Popolo.

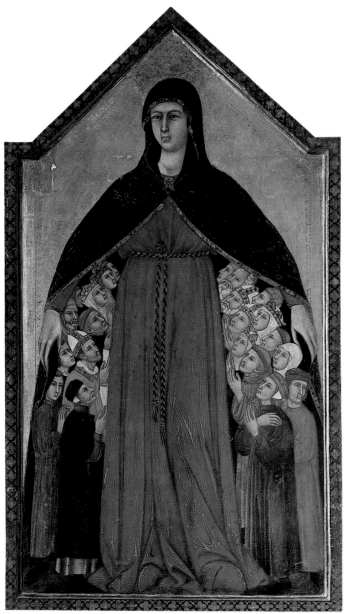

very important for the development of painting in Perugia until well into the second half of 14th century. The robust but anonymous painter known simply as the **"Maestro di Città di Castello"** also belonged to the Duccio circle, while **Memmo di Filippuccio** broke away from it. The latter probably worked with Giotto on the frescoes in Assisi, and from 1303 until at least 1317 he was active at San Gimignano, where he was a sort of official painter for the Commune, while in 1321 and 1324 there is documentary evidence that he was in Siena. Recent critics have justly stressed his importance, since it was he who first introduced the art of the early Giotto to Siena, then dominated by the cultural values of Duccio. Besides his work as a miniaturist and as the author of a number of paintings on wood, he was very active in fresco, and among other things has been credited with the cycle of frescoes in the "Stanza del Podestà" in the Palazzo del Popolo in San Gimignano. Depicting a love-story, it derives part of its interest from the way in which contemporary customs are illustrated. Moreover, in 1980-81 a very fine picture of a *Surrender of a Castle* came to light in the "Sala del Mappamondo" in the Palazzo Pubblico in Siena, and it is possible that this might belong to the late period of Memmo di Filippuccio, when he was being influenced by Simone Martini.

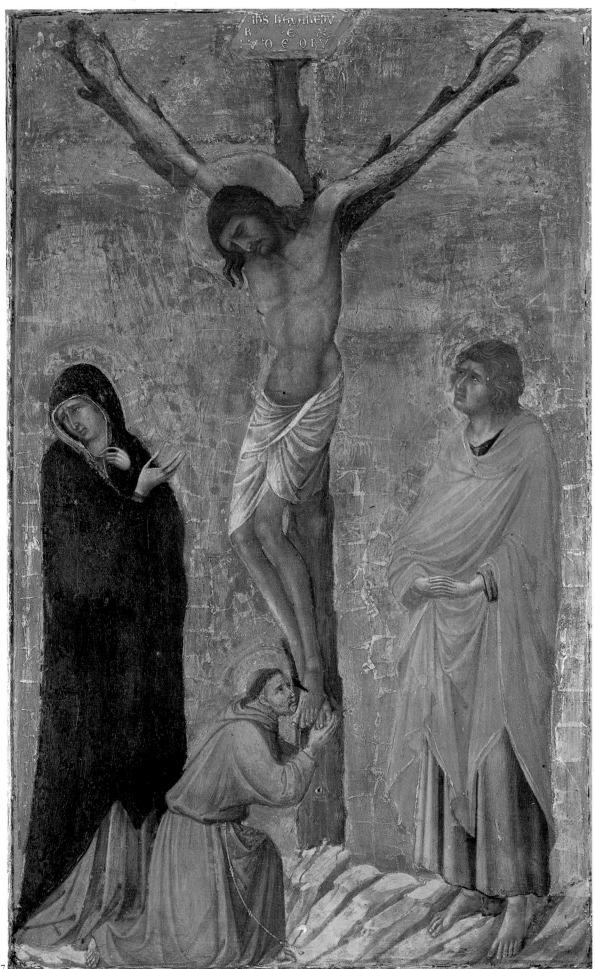

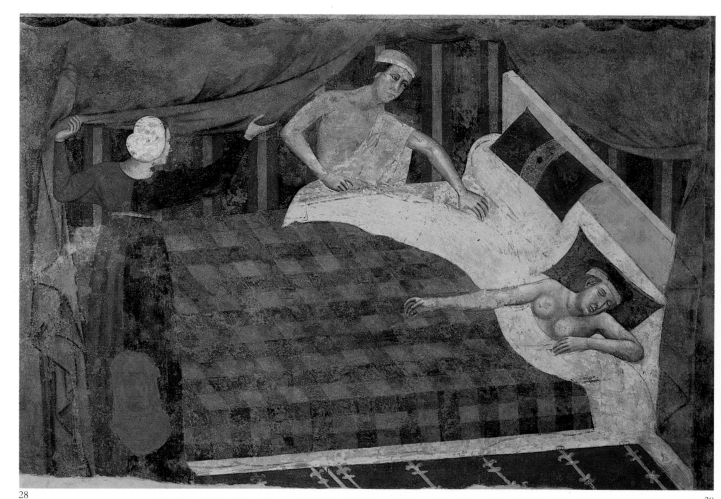

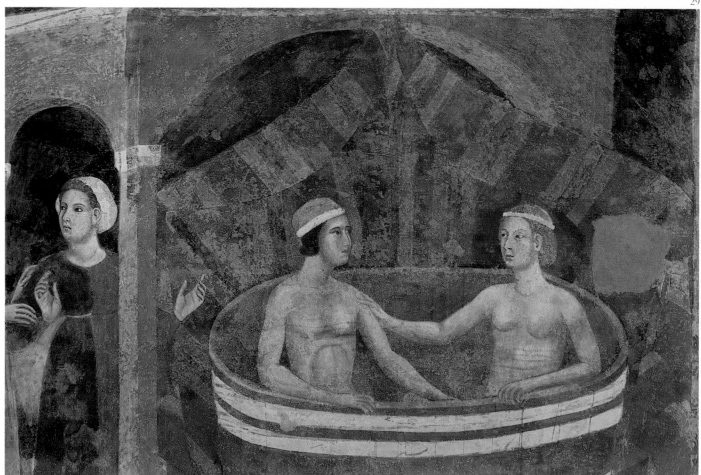

# The 14th Century

Duccio's Maestà had not been in place on the High Altar in the Cathedral for five years when another grand Maestà, this time in fresco, was painted on the main wall of the great hall in the Palazzo Pubblico in Siena. An inscription in verse bears witness to the fact that it was finished in 1315. It is the work of **Simone Martini**, and the fact that we have no previous information about this artist (and yet he must have been already famous and highly appreciated, since with Duccio still alive he nevertheless got the first important commission ever given to a painter by the Commune of Siena) still poses the question of how he learnt to paint and what he had previously done. Various hypotheses include a journey to France in his youth, and the more likely theory that he worked in Duccio's studio, even if he cannot with any certainty be identified with the painter who supposedly collaborated on the panels of the Maestà. From Duccio's great work Simone Martini takes over the basic theme of glorifying the Virgin as the Queen of Heaven, but he departs from Duccio not only in style, but also in concept. The secular, as opposed to religious, intentions of Duccio were barely referred to in the dedicatory inscription, while Simone's Maestà at once assumes a decidedly political colour in the two beautiful stanzas, reminiscent of Dante, inscribed on the steps of the Virgin's throne. In them the Virgin herself, addressing the Angels and Saints, warns them that the offerings of flowers and prayers with which they are interceding in favour of the city will be given in vain by those who betray her or who oppress the humble. Not only that, but the severely liturgical timelessness of Duccio's vision is here transmuted into a solemn procession that halts in order to present the flowers to the Madonna, whose throne is shaded by a billowing silk canopy supported on slender rods held up by the Saints. Even more original is the way the scene is constructed within a large flat frame containing twenty medallions with busts of Christ, Apostles, Prophets and Doctors of the Church separated by civic coats of arms, and opening up a space with real depth to it, such as must presuppose a knowledge of Giotto's sense of space.

Here, around the Virgin's wooden and gilded throne, delicately carved and pierced as a piece of exquisite jewellery, the worshippers press forward in groups that are no longer rigorously symmetrical, and whose poses seem studied with a view to underlining the musical continuity of their profiles and the superb linear rhythms of their softly draped garments. Right from this first surviving work, and in spite of the respects in which he dovetails with Duccio, Simone has a more concrete and almost naturalistic vision of space, while his figures are far more individualized in human terms, so that his whole way of painting appears to mark a break with the crystalline world of the Byzantine tradition, with a suggestion of the Gothic taste from north of the Alps, and evidence of those new directions and experiments in terms of form that came with the spread of Giotto's pictorial idiom.

It should also be pointed out that the fresco was painted on a wall impregnated with damp, since it was above the Commune's salt warehouse, and very soon suffered damage, so that in 1321 Simone himself had to repaint the heads of at least eight figures, including those of the Madonna and the Child. The difference between those done in 1315 and the ones repainted six years later is quite clear, in that the first are still rather in the manner of Duccio, while Martini's ideal of beauty had been evolving rapidly in the meantime, and had already found its most important expression in a polyptych painted in 1319 for the Dominicans in Pisa and now in the museum there.

But before this date the artist had been active in Naples, where on July 23rd, 1317 King Robert of Anjou gave him a stipend of fifty ounces of gold on the occasion of his investiture as a knight. The only remaining work from his period in Naples is a beautiful painting now in the National Museum of Capodimonte. It shows *St. Louis of Toulouse Offering the Crown of the Kingdom to His Younger Brother Robert and Receiving the Heavenly Crown of Sainthood from Two Angels*. With the intention of celebrating the canonization of this saint, the picture shows him full face, seated on a throne, and wearing a gorgeous cope all wrought with gold that contrasts dramatically with the humble Franciscan habit just beneath. The absorbed and almost bloodless face is both formally and spiritually akin to that of a very famous *St. Clare* (or perhaps St. Margaret) which is part of a group of five Saints in half-bust frescoed in the right-hand transept of the Lower Basilica at Assisi. We may therefore consider it possible that on his return from Naples to Tuscany, in about 1318, Simone stopped at Assisi, where in fact he returned not long afterwards to carry out his vast frescoes.

Belonging to the same period as the Pisa polyptych, composed of no fewer than forty-three half-bust figures characterized by the wonderful flowing quality of the lines that so incisively articulate the forms in space, is a polyptych painted in 1320 or 1321 for the Dominican church in Orvieto (now in the Cathedral Museum there), as well as other works either in Orvieto or originating there, in which the hand of assistants can be traced. But the most amazing creation of this period is the *Madonna and Child* discovered in 1957 under a mediocre late 16th-century repainting in the church of Lucignano d'Arbia (now in the Pinacoteca in Siena, unnumbered). The gold and blue of the Virgin's cloak had been stripped off to make the new paint stick better, but this work nevertheless emanates the most extraordinary charm, thanks to the particular sweetness of the Madonna's expression and the fact that the Child, in contrast with traditional iconography which showed him as already a "puer," that is, aware of his own actions in raising his hand in blessing or turning towards his mother, here appears as an "infans" of the tenderest age, and still wrapped in swaddling clothes as in a Nativity.

The lack of any documents concerning the artist between 1324 and 1326 lends support to the hypothesis that during this period he was away from Siena working on the frescoes for the chapel of St. Martin in the Lower Basilica at Assisi. For this chapel, as early as 1312, Simone had made the drawings for the wonderful stained-glass windows. Eight Saints in full figure beneath three-lobed tabernacles adorn the archway of the entrance, while above is the scene of the *Dedication of the Chapel*. On the walls are ten episodes from the life of St. Martin, carried out with a clear and measured sense of space with regard to the relationship of the figures and the architectural features, while the influence of Duccio has been completely superseded. The narratives dealing with this saint, admirably concrete in manner and transferred with precision into the painter's own times, give a feeling of surprising and bold naturalism. As examples we might mention the

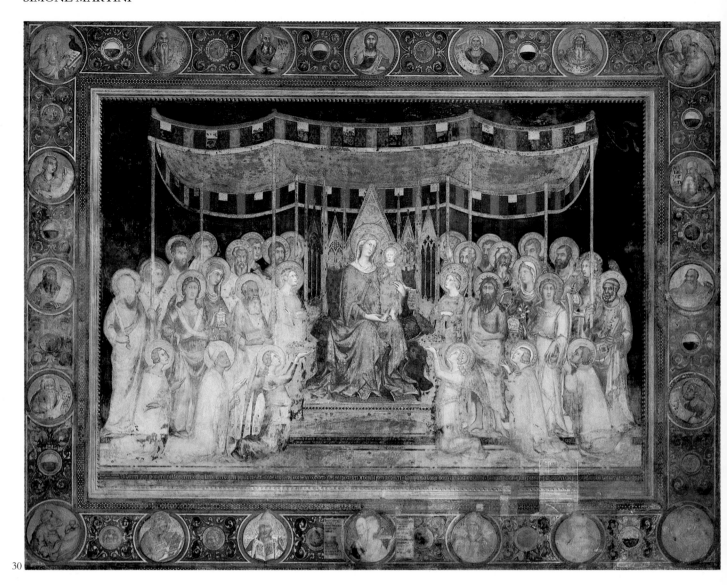

30

fat singing friars in the scene of the *Funeral* or the gaily dressed troubadours in the *Investiture*, perhaps a recollection of the ceremony he had himself taken part in in Naples. But there are also more contemplative moments, such as the white chapel where the saint sits in meditation, or the lyrical evocation of the atmosphere of a Gothic church in the wavering light of torches that echo the golden highlights of the vestments in the *Funeral*.

The theme of knighthood, touched on in several episodes of the life of St. Martin, occurs again in purely secular terms in the famous portrait of *Guido Riccio da Fogliano* frescoed on the wall opposite the Maestà in the Palazzo Pubblico in Siena. It bears the date 1328, the year in which this "honourable Captain of War" overran the fortress of Montemassi, which had become a hideout for Ghibelline outlaws and which we see depicted on the left of the scene. On the right is the "bastita" or fortification built by the Sienese during the siege, along with the camp of tents interspersed with the black and white banners of Siena. Between these two constructions is the knight himself, clad in a rich panoply embroidered with the same motifs as those on the saddle-cloth of his horse. It is an image of epic solemnity that stands out against a dark blue sky (repainted, but in keeping with the original), and rises in solitary splendour above a bare landscape, which with its undulating lines echoes the sinuous curves of the horse's saddle-cloth.

Dating from more of less the same time as the *Guido Riccio*, that is about 1330, is the altarpiece of the *Blessed Agostino Novello*, formerly in the church of Sant'Agostino in Siena and now in the Cathedral Museum. In the middle rises the figure of the holy man, infused with a kind of meditative sweetness. In accordance with the 13th-century style he is flanked by four compartments narrating four of his miracles. This Agostino died in 1309, and Simone has given us a gently moving account of small happenings, mostly concerning children or domestic matters, set with scrupulous realism in the courtyards, the alleyways overshaded by loggias and the houses of the genuine domestic Siena of the 14th century, while one of the scenes – that of the horseman who has fallen into a crevasse – takes place in the bare rolling hills that lie immediately to the south of the city.

**Simone Martini**
30. *Maestà*. Palazzo Pubblico.
31. *Maestà, detail, Madonna and Child.*

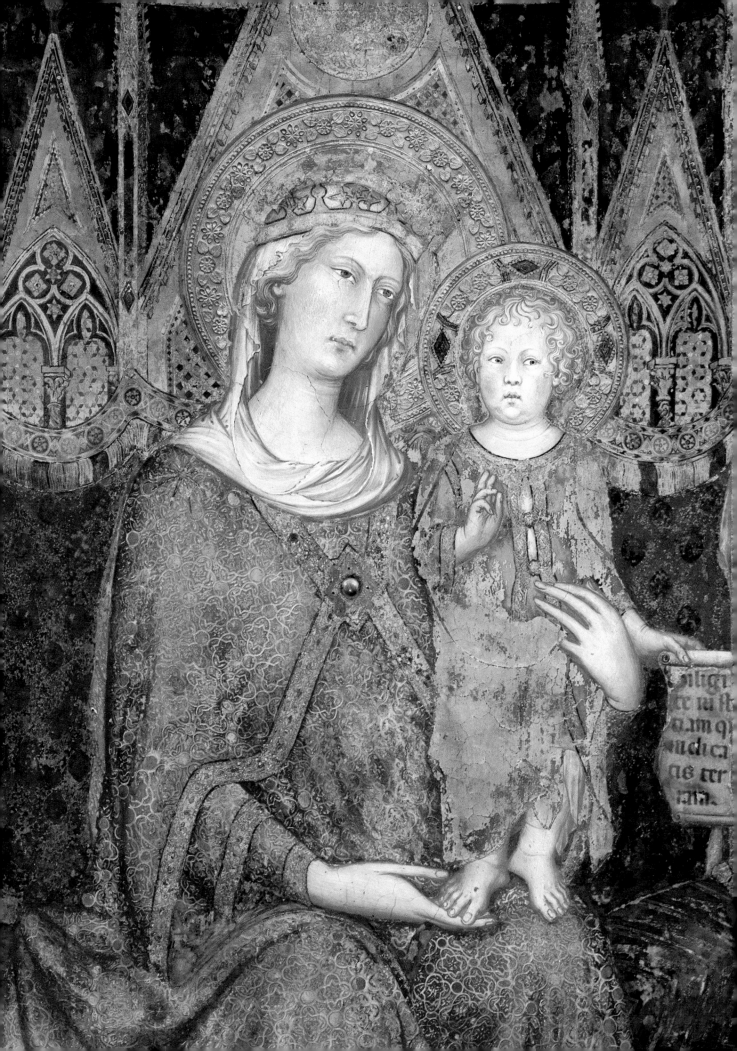

The text on the scroll held by the Child appears to read:
...ligi...
...ti in ...
...am q...
...udicia...
...s ter...
...ra...

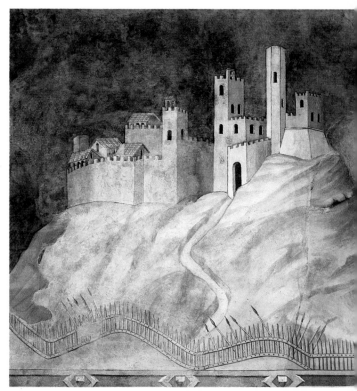

32

**Simone Martini**

32. *Funeral of St. Martin.* Assisi, Lower Basilica.
33. *St. Martin receives the Knighthood.* Assisi, Lower Basilica.
34. *Madonna and Child.* Pinacoteca.
35. *Guido Riccio da Fogliano.* Palazzo Pubblico.
36. *The Blessed Agostino Novello.* Cathedral Museum.

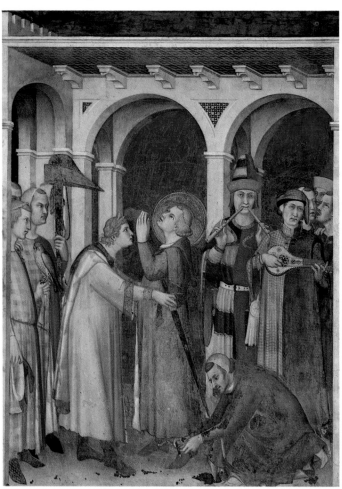

33

34

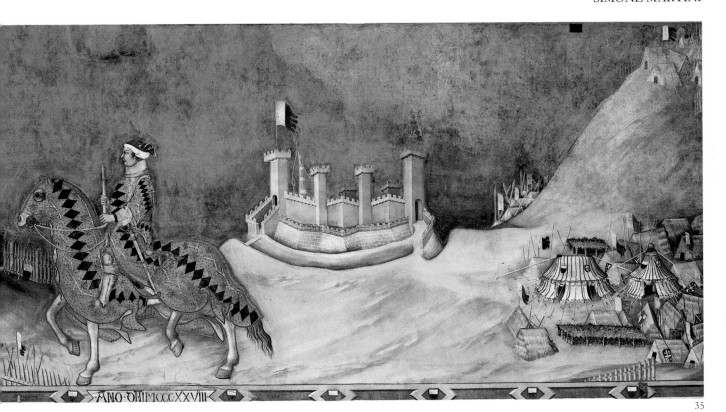

35

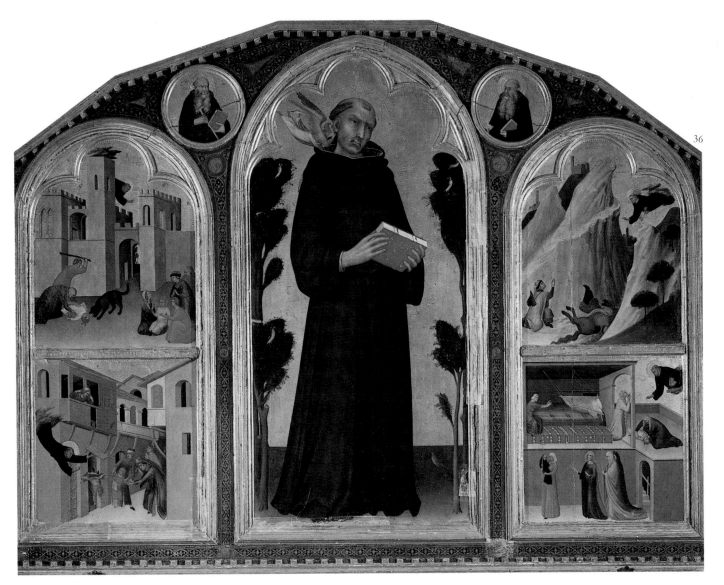

36

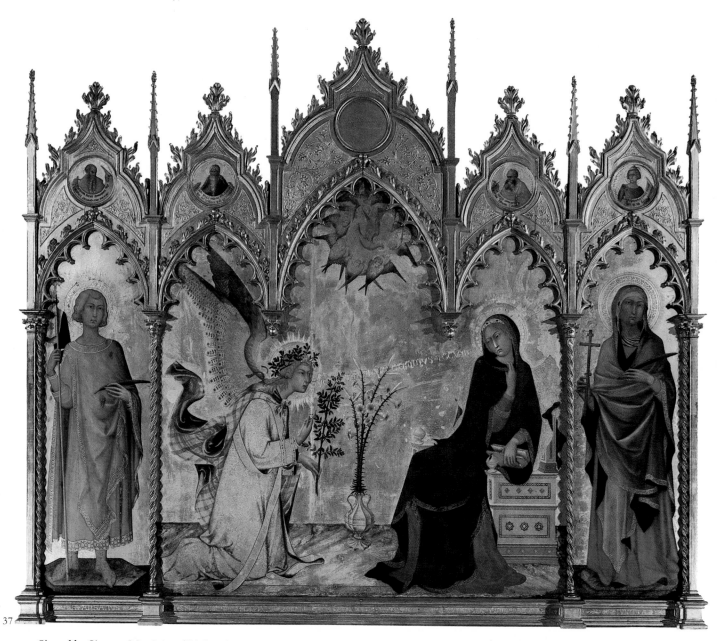

37

Signed by Simone Martini and his brother-in-law Lippo Memmi, and dated 1333, is the triptych showing the *Annunciation* with *St. Ansano* and *St. Margaret*, formerly in the Cathedral of Siena and now in the Uffizi.. We do not know what part Memmi played in this, though critics tend to credit him with the two saints in the side panels. However, these differ very little in style from the central panel, which is one of Simone's supreme masterpieces. The painting takes the Gothic taste for sheer line to the extreme limits of melodic expressiveness, and it is this line, with its impetus, its inflexions, its sinuous cadences, that expresses the very bodilessness of the Angel and the Madonna, whose gestures seem perfectly weightless, on the point of vanishing into the great gold light of the background. But at the same time Simone was thinking again about the iconographical hints and motifs implied in Duccio's Maestà, and with his nervous line and accents of intense feeling translated them into the *Polyptych of the Passion*, the small panels of which are now split up between the museums of Antwerp, Berlin and the Louvre. This portable polyptych was done for Cardinal Napoleone Orsini, probably before Simone left for Avignon in 1336.

The artist spent a long time in the papal city, and died there at the end of July 1344, but there is relatively little evidence of his activity in Avignon. One item is the panel depicting *The Child Jesus Returns from the Disputation in the Temple*, now in the Walker Art Gallery in Liverpool, which bears the painter's signature and the date

1342. The unusual subject and the lively presentation of the characters are a foretaste of so much intimist and narrative painting of the late 14th- and early 15th-century painting in the north of Europe. But Martini's years in Avignon, where among other things he formed a deep friendship with Petrarch, were of fundamental importance to the development of painting not only in France, but over a vast area including Flanders, Bohemia and Catalonia, forming a solid basis for the flourishing of what has come to be called "International Gothic."

**Simone Martini**

37. *Annunciation with St. Ansano and St. Margaret.* Florence, Uffizi.
38. *The Child Jesus Returns from the Disputation in the Temple.*
    Liverpool, Walker Art Gallery.

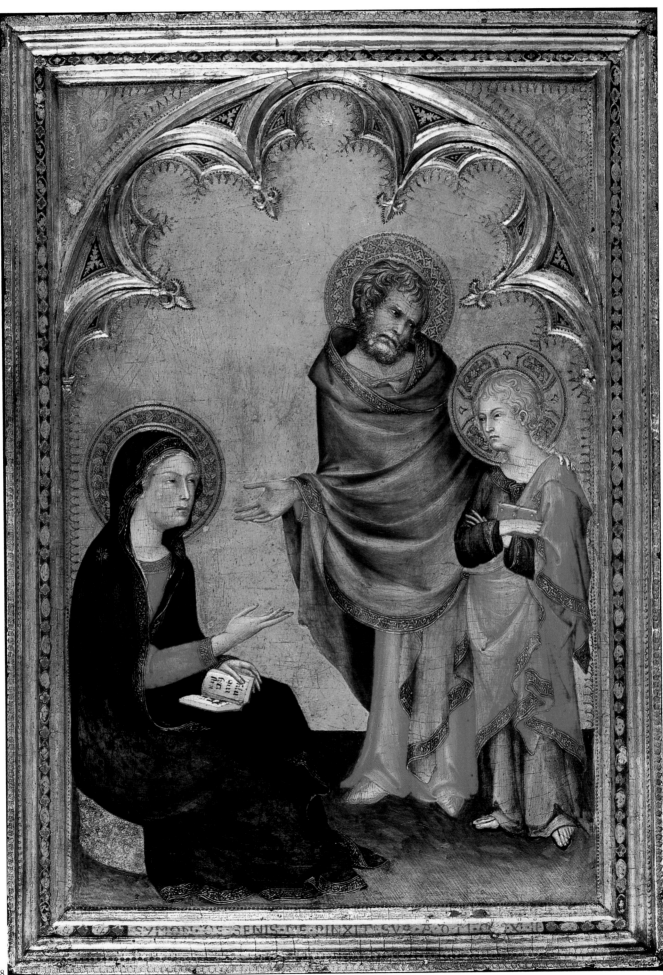

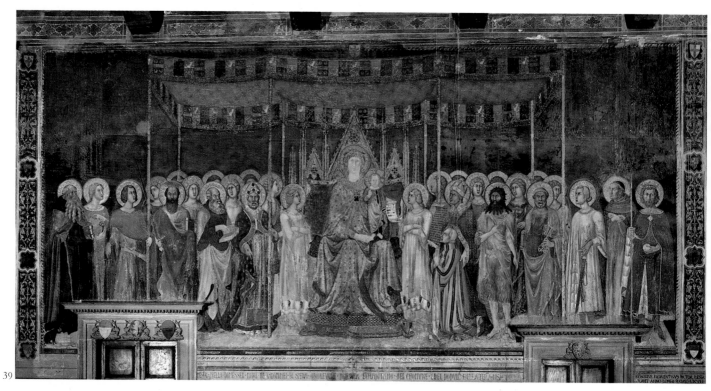

39

A faithful collaborator and follower of Simone Martini was his brother-in-law **Lippo Memmi**, son of the above-mentioned Memmo di Filippuccio, together with whom in 1317 he worked in the Palazzo del Popolo in San Gimignano on the fresco of the *Madonna Enthroned among Angels and Saints and the Podestà Messer Nello di Mino de'Tolomei*. It has a slight coldness and monotony that recalls the Maestà painted two years earlier by Simone Martini. He became Simone's brother-in-law in 1324 and collaborated with him on the *Annunciation* of 1333. Apart from the fine *Madonna dei Raccomandati* in the Cathedral of Orvieto, signed LIPUS DE SENA, his fame rests above all on a number of panels showing the *Madonna and Child* in half-bust, now in the State Museum of Berlin, the Pinacoteca (no. 595), the church of the Servites in Siena, the Altenburg Museum, and the National Gallery in Washington. In these his intimist art finds happy and coherent expression in an extraordinary finish and cristalline clarity of line, which, though it may not have the breadth of Martini himself, derives its intense and subtle linear quality from him, while adding a few graphic features that are peculiarly his own.

One of his masterpieces is held to be a frescoed Maestà in the cloister of San Domenico in Siena, of which there remains an impressive fragment detached in 1971. Recent criticism also credits him with the large panel of *The Triumph of St. Thomas* in the church of Santa Caterina in Pisa, mentioned by Vasari as the work of the Pisan painter Francesco Traini. In 1341 he had a hand in the building of the Torre del Mangia (the lofty tower of the Palazzo Pubblico in Siena), and is credited with the beautiful bell-tower at the top. After acquiring considerable wealth, he died in Siena in 1356.

Lippo Memmi is now generally credited with the *Stories from the New Testament* frescoed on the right-hand wall of the Collegiate Church of San Gimignano, while some critics have attributed them to his brother Federico. On the other hand tradition, following in the footsteps of Ghiberti and Vasari, assigns them to a certain "**Barna**" or "**Berna**," who is supposed to have died in 1381 by falling off the scaffolding while at work on them. However, this date is certainly too late, because the style of those frescoes, substantially independent of the manner of the Lorenzetti brothers, is not seen after the fourth or fifth decade of the 14th century and is closely linked with that of Martini, and even more with that of Memmi, although it does not inherit his taste for line. On the contrary, it almost aggressively rejects this in favour of experiment in volumes that rely not so much on light and shade as on a rather harsh quality of drawing and an intense

formal and compositional simplification that have led some critics even to speak of archaism. They give evidence of an artistic personality with an outstanding sense of drama, much of which relies on the gestures of the characters, sometimes so violently expressive as to be crude. All the same, these paintings reveal an instinct for drama and an almost "folk" vigorousness.

So the most prudent course is to continue to attribute them to "Barna," although we know very little about this painter: he has been credited with a handful of other pieces, including a *Madonna* in the Museum of Sacred Art in Asciano, near Siena. The only document that mentions him is a reference to a certain "Barna di Bertino," who in 1340 was one of the Jury of the "Tribunale della Mercanzia" in Siena.

**Lippo Memmi**
39. *Madonna Enthroned.* San Gimignano, Palazzo del Popolo.
40. *Madonna Enthroned, detail.*
41. *Fragment of a frescoed Maestà.* Pinacoteca.

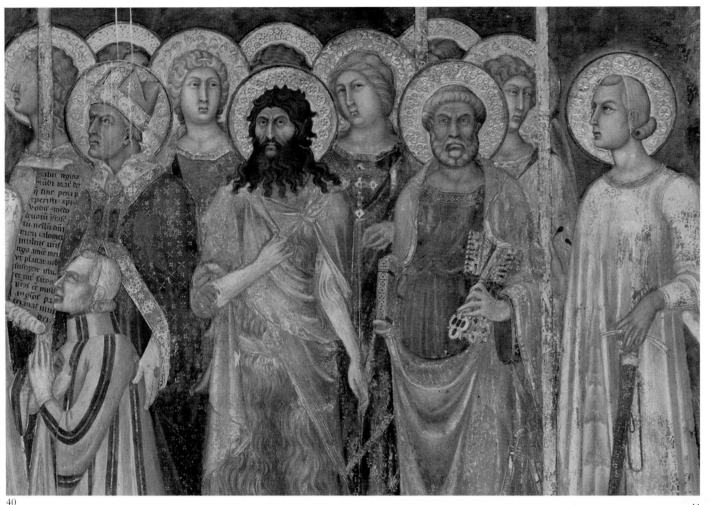

40

41

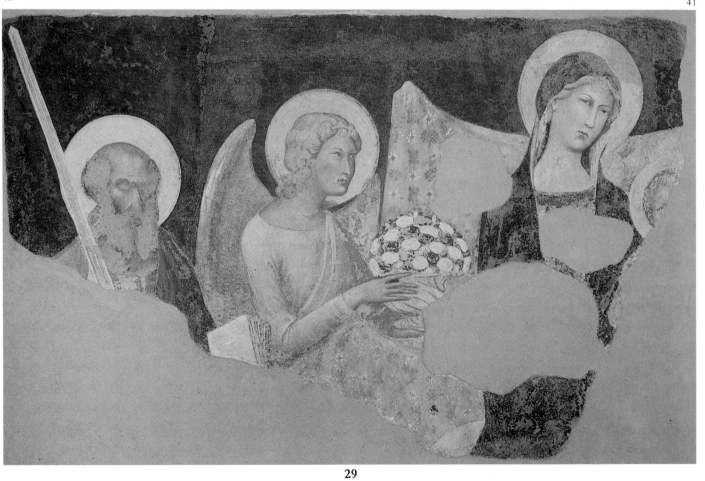

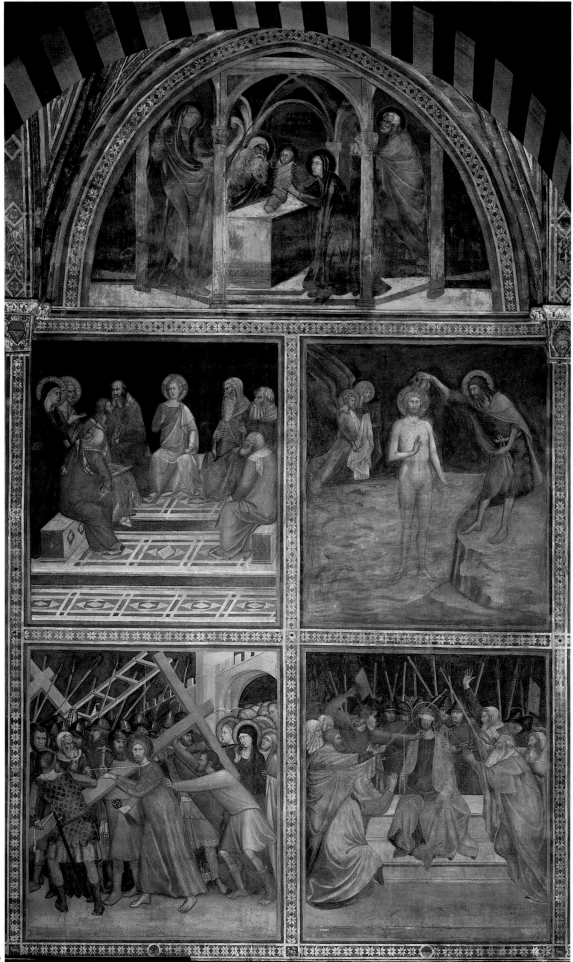

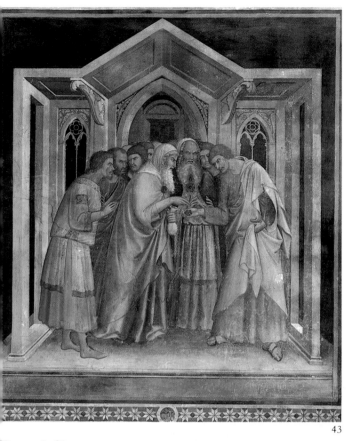

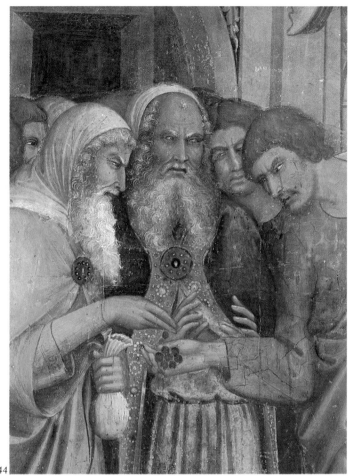

43

44

**Barna da Siena**
42. *Stories from the New Testament.* San Gimignano, Collegiate Church.
43. *Judas Betrays Christ.*
44. *Judas Betrays Christ, detail.*
45. *Kiss of Judas.*
46. *Kiss of Judas, detail.*

45

46

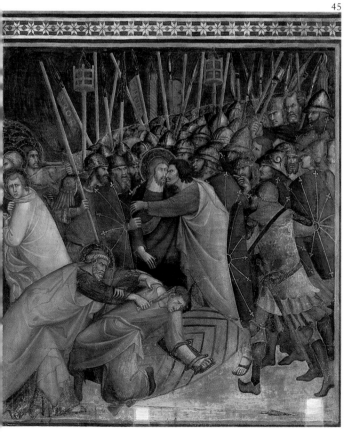

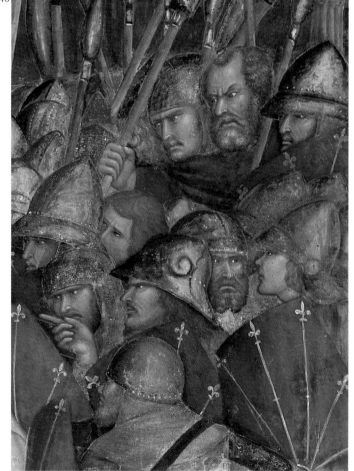

47

**Pietro Lorenzetti**
47. *Polyptych*. Arezzo, Santa Maria della Pieve.
48. *Deposition*. Assisi, Lower Basilica.

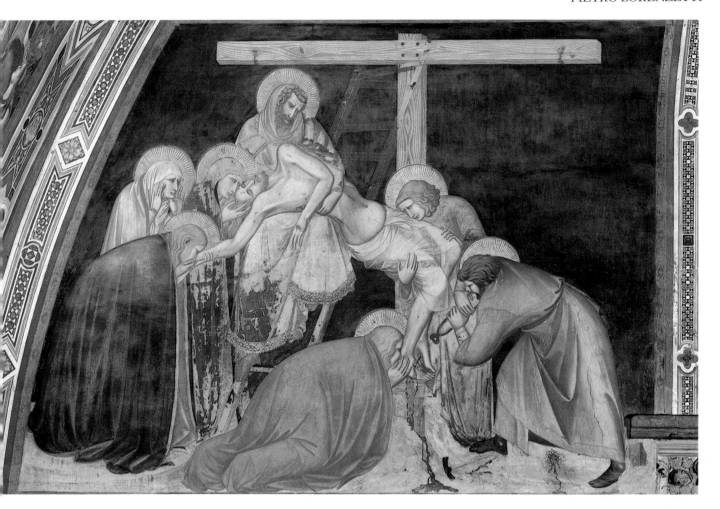

With the brothers **Pietro** and **Ambrogio Lorenzetti** Sienese painting defined its own position in relation to the current which sprang up in Tuscany and was to assert itself as the most revolutionary event in 14th-century art: the "popular" style of Giotto as opposed to the Byzantinism of Duccio and the International Gothic of Simone Martini. All the same, if Giotto's lesson was at the basis of the artistic experience of both the Lorenzetti brothers, each of them assimilated and developed it in a manner totally personal and independent one from the other, so that their styles cannot be confused in any way.

The elder of the two was probably Pietro, if it was he who was paid for a painting, now lost, by the Commune of Siena on February 25th, 1306. But most recent criticism tends to see his earliest surviving work in the *Six Stories of the Passion* at Assisi, frescoed on the ceiling of the left-hand transept of the Lower Basilica. The style is still linked to that of Duccio's Maestà, and the same can be said of the *Madonna and Child* in a mural triptych in the Orsini Chapel in the same basilica, while the figures of St. Francis and St. John the Baptist that flank it, beneath an ornate Cosmatesque loggia, resemble Giotto's figures in the vigorous way in which they are modelled.

However, Pietro's earliest work of certain date is the grandiose polyptych painted in 1320 on commission from Bishop Guido Tarlati and destined for Santa Maria della Pieve at Arezzo. In the proud and almost aggressive personalities in the picture, and in the static solidity of their forms, there may be an echo of the great statues carved twenty years before by Giovanni Pisano for the Cathedral of Siena, particularly in the central group, where Pietro reworks the touching motif of the exchange of glances between the Madonna and the Child. And the painter took up this theme again, infusing it with all its implications of love and intimacy, in a stupendous painting done a little later, formerly in the Cathedral and now in the Diocesan Museum of Cortona, and in other treatments of the Madonna right up to the one dated 1340, formerly in Pistoia and now in the Uffizi.

In the years 1324-25 and 1327-28 the painter probably went back to Assisi to continue the cycle of the *Passion of Christ* which he had begun over ten years before. And especially in the *Crucifixion*, the *Deposition* and the *Entombment* he succeeded in creating one of the supreme examples of the dramatic genius typical of the 14th century in Italy, with the plastic quality of the volumes summed up in clear, incise profiles very far from the gentleness of the Gothic linear style, accompanied by notes of delicacy, vehemence and fearful grief. Similar both in style and spirit is the no less dramatic *Crucifixion* formerly in the Chapter House and now in the church of San Francesco in Siena, and which according to a 16th-century authority dates from 1331, though a somewhat later date seems likely. And a *Risen Christ* of almost sculptural impressiveness and majesty was recently detached from the wall of the Chapter House of the same Monastery.

Dating from 1329 is the most solemn and splendid of Pietro's altarpieces, executed for the church of Santa Maria del Carmine in Siena, and now preserved in part in the Pinacoteca (unnumbered). Especially in the predella, with its five *Stories of the Carmelite Order*, the artist gives ample proof of his exceptional narrative talents both in the broad compositional structures which even involve the use of perspective and in the great skill with which the details of the surroundings are done.

In the early use of perspective Pietro's experiments, though with rather different results, coincide with those of Ambrogio, and in 1335 the two brothers collaborated for the only time on a cycle of frescoes showing *Scenes from the Life of the Virgin*, on the outside of the church of the Spedale della Scala in Siena. Frequently imitated throughout the 14th century, it was destroyed in the 18th.

An even bolder and more intelligent use of space, clearly defined in a whole series of perspectives provided by the architectural features, but also involving the figures set in them, is evident in the altarpiece showing the *Nativity of the Virgin*, done by Pietro in 1335-42

49                                50

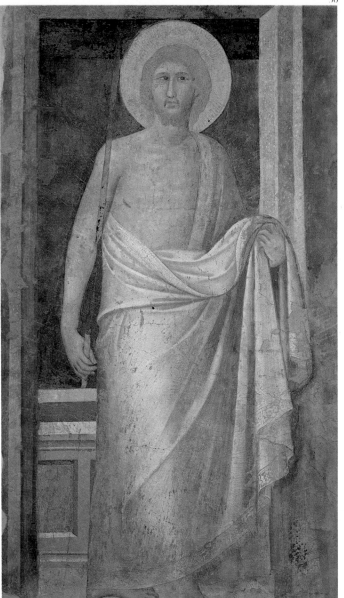

for the Cathedral of Siena, and now in the Cathedral Museum. (Already in the small fresco beneath the monumental *Crucifixion* in the Basilica of Assisi, the half-bust figures of the *Madonna and Child*, St. Francis and St. John the Evangelist were linked together in such a way as to break with the traditional isolation typical of triptychs, and giving rise instead to a "holy family" composition, with the Madonna pointing to the Child, who in turn is blessing her, and St. Francis showing the stigmata in his side while St. John looks on at the whole scene.) On account of its shape and internal divisions, the *Nativity of the Virgin* is in fact a triptych, but the painter has broken through the usual scheme of distribution, using the central and right-hand panels for a single scene, thus achieving an airy and well-defined space quite capable of containing the monumental structures of the women in the principal scene, in contrast with the narrowing perspective of the left-hand panel, in which a youth brings the anxious Joachim the news of the happy event. The Nativity itself takes place in the elaborate room of a 14th-century mansion, graced with coloured fabrics, light-coloured hangings and ceilings painted deep blue. But the protagonists, from St. Anne who lies like the image of a matron on the lid of an Etruscan sarcophagus to the two motionless and composed serving-women and the seated visitor, possess a statuary solidity and an august gravity in which they resemble the lovely angels on either side of the Madonna's throne in an altarpiece dated 1340, formerly in San Francesco at Pistoia, now in the Uffizi. In this picture the mingling of sculptural quality, derived from Giotto, with the shining purity of Sienese colouring creates a vision of sovereign equilibrium, strength of construction and gentle and radiant luminosity. Other works in fresco and on wood, distributed over a certain length of time, bear witness to Pietro's career. The last documentary evidence dates from 1341 to 1345, and shows that he was resident in Siena, where he probably died as a victim of the terrible plague of 1348.

**Pietro Lorenzetti**
49. *Madonna between Two Saints.* Assisi, Lower Basilica.
50. *The Risen Christ.* Pinacoteca.
51. *The Carmine Altarpiece.* Pinacoteca.

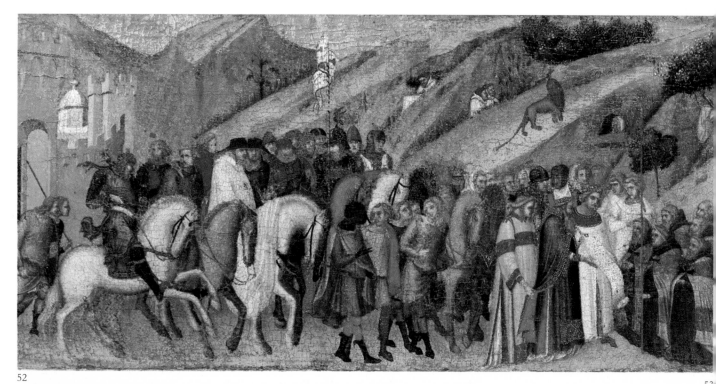

52

53

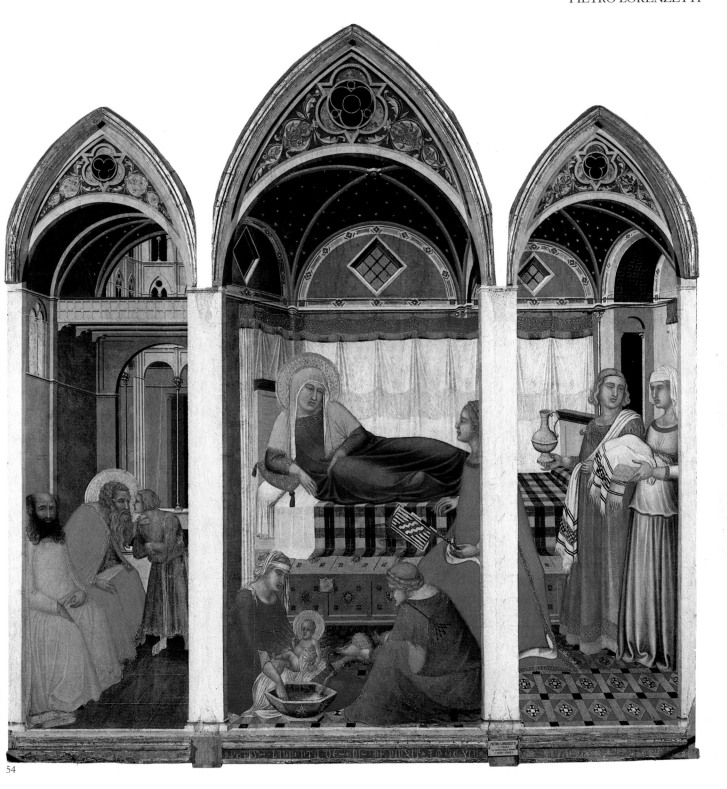

54

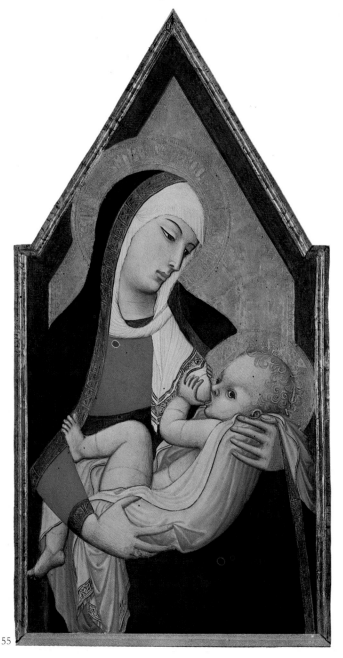

55

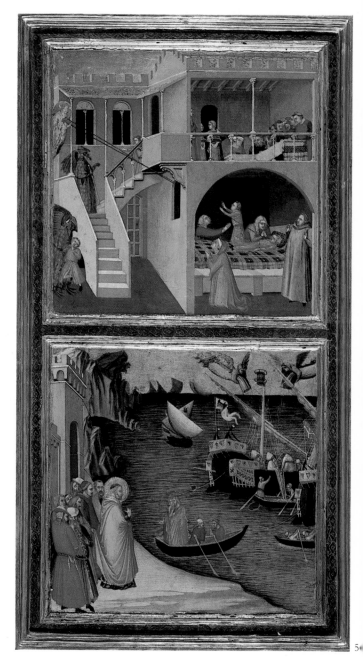

5(

**Ambrogio Lorenzetti**

55. *"Madonna del Latte."* Archbishop's Palace.
56. *Two Miracles performed by St. Nicholas.* Florence, Uffizi.
57. *Two Miracles performed by St. Nicholas, detail.*

The peaceful and gently lyrical temperament of Ambrogio Lorenzetti is in complete contrast to his brother's fiery and often intensely dramatic spirit. Vasari did not realize that the two were related, and wrote of Ambrogio that his manners "were... more those of a gentleman and philosopher than those of an artist," and he speaks about his love of literature and his intellectual acumen, qualities that enabled him to turn his hand both to sacred painting and to historical, allegorical and other "profane" themes, to pick up hints from classical antiquity and from the fabled Orient, to be a cosmographer and cartographer, and above all to bring profundity and boldness of ideas to his work, and to revolutionize accepted notions of iconography.

Unlike Pietro, Ambrogio shows no signs of the influence of Duccio in his painting. He is known to have been in Florence earlier than 1321, and his earliest known painting was found in Florentine territory: dated 1319, it comes from the church of Sant'Angelo at Vico l'Abate, and is now in the Museo di Cestello in Florence. However, the spirit of Giotto visible even in this work does not tend, as in Pietro, to create three-dimensionality by means of strong contrasts of colour and of light and shade, but rather to define the structure of the forms by a precise vigour of outline, and with strong lines surrounding clear and vivid chromatic planes. Even his

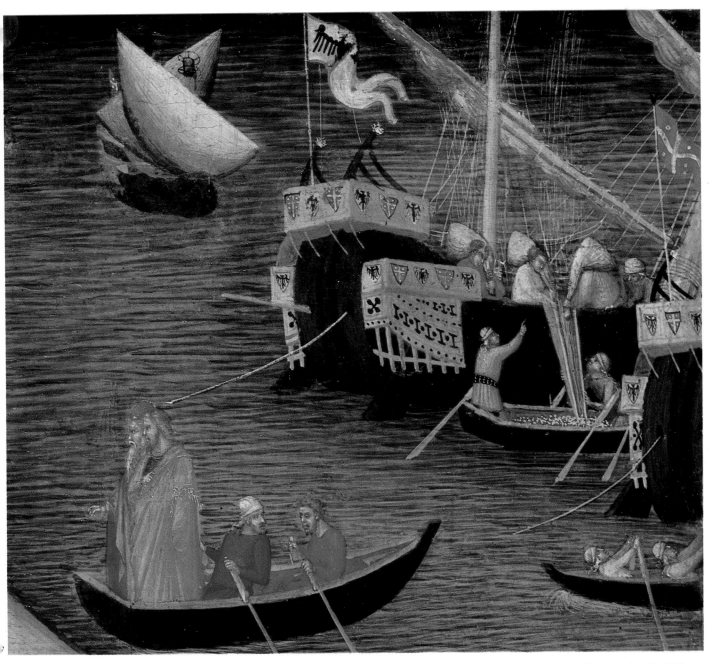

experiments in perspective, which Ambrogio pursued instinctively and in which he attained some fascinating results, are to be seen in this tension between line and colour.

In 1324 the artist was in Siena, where he must have done a lot of work, as we see from numerous pictures including – presumably in this period – a *Madonna* at Brera and the famous *Madonna del Latte*, formerly in the monastery of Lecceto and now in the Archbishop's Palace in Siena. The calm, gentle and interconnected development of the linear structures here bind the image of the Child to that of the Mother in an admirable and moving unity of composition. But in 1327 he is recorded as being a member of the "Arte dei Medici e Speziali" in Florence, the guild to which painters and pigment merchants also belonged. Two important altarpieces used to be in the Florentine church of San Procolo, a triptych which seems once to have borne the signature and the date of 1332, now vanished, and which was reconstructed at the Uffizi in 1959, and an altar-frontal, which like Martini's altarpiece of the Blessed Agostino Novello, appears to have had in the centre an image of St. Nicholas of Bari, now either lost or unidentified, flanked by four panels depicting miracles performed by the Saint, now preserved in the Uffizi. In these panels the artist may have given one of the earliest proofs of his skill at architecture and landscape, qualities that foreshadow the frescoes of

the *Good and Bad Government*: the great frescoes in the Palazzo Pubblico in Siena which allegorically sum up so much of the ideals of 14th-century Tuscany, and incidentally give us a most wonderful and exact picture of the daily life and customs of the time.

His earliest attempts at fresco consist of two scenes formerly in the Chapter House, but detached in 1875 and transferred to the church of San Francesco in Siena. They depict *St. Louis of Toulouse Bidding Farewell to Boniface VIII* and the *Martyrdom of Franciscan Missionaries at Ceuta* in Morocco. These are usually dated in 1335-36, but may be a few years earlier, and they bear witness to his singular adherence to historical reality in all its forms. Thus in the first we are given an acutely perceived image of the refined and authoritative society of the court and curia, while more exotic and out of the way human types and customs are represented in the second with equal realism and immediacy.

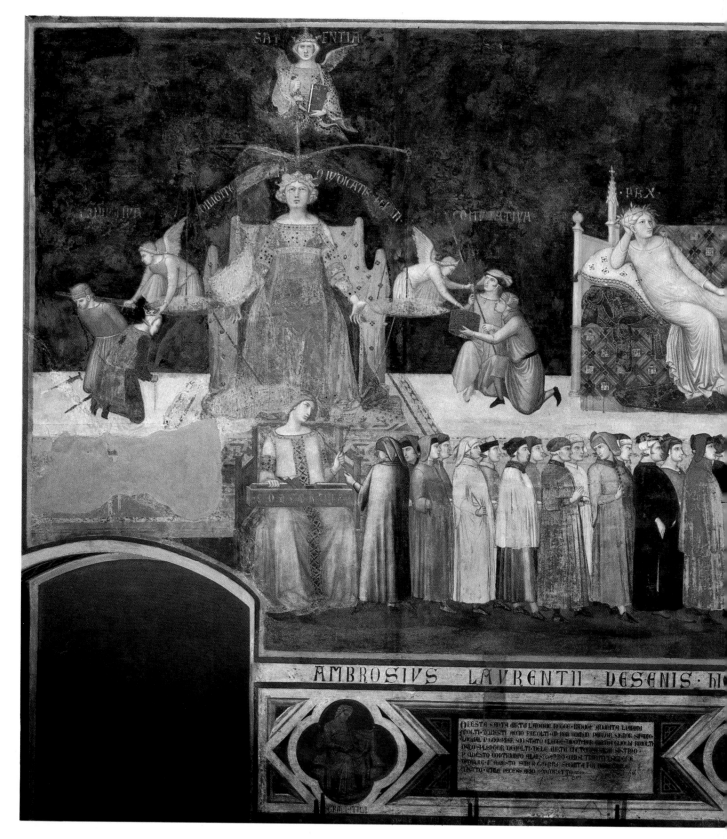

But the work that has done most for Ambrogio's reputation is the cycle of frescoes of the *Allegories* and the *Effects of Good and Bad Government* painted between 1337 an 1339 in the "Sala dei Nove" of the Palazzo Pubblico in Siena. The aim of the painting is to exalt the political creed of the government of the "Nove" (the Nine), who were Guelphs and retained power in Siena until 1355. It elaborates on two themes already foreshadowed in the inscriptions on the Maestà of Simone Martini: that of Justice on the one hand, and on the other the subordination of private interests to those of the common good, according to a concept of Aristotelian origin that was expressed in the

work of St. Thomas Aquinas and popularized in the early 14th century by the Dominican friar Remigio de' Girolami. The painting works essentially on two levels, one allegorical and symbolic and the other concerned with description and exemplification, while the whole cycle covers three walls of the great hall. On the wall opposite the window, 7.7 metres long, is *Allegory of Good Government*. This is personified by the Commune, represented by a venerable old man dressed in the colours of the "Balzana," the black and white Sienese coat-of-arms, seated on a throne and surrounded by the four *Cardinal Virtues* and by *Magnanimity* and *Peace*. Homage is being paid to these

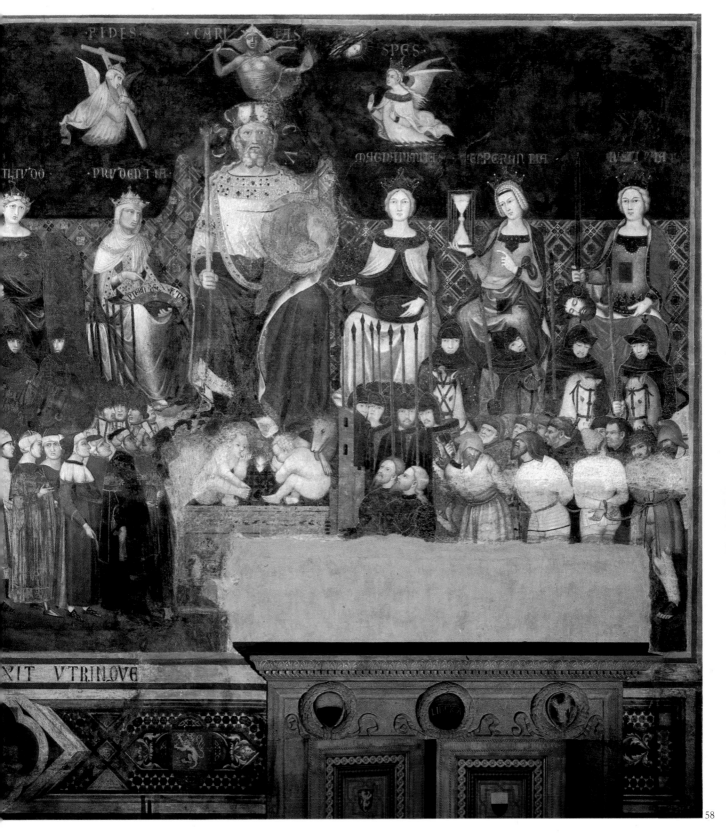

**Ambrogio Lorenzetti**
58. *Allegory of Good Government*. Palazzo Pubblico.

figures by twenty-four citizens (in memory of the government of the Twenty-Four, which between 1236 and 1270 marked the entry of the common people into the government of the Commune, though they are also symbolic representations of the various civic officers and magistrates), and these are linked by two woven cords ("concordes") which *Concord* gathers up from under the scales of *Justice* at the instigation of *Wisdom*. Above Good Government are the three *Theological Virtues*, and at his feet is the she-wolf with the twins Romulus and Remus, an allusion to the Roman origins of Siena. On the right are fully-armoured knights and foot-soldiers symbolizing the

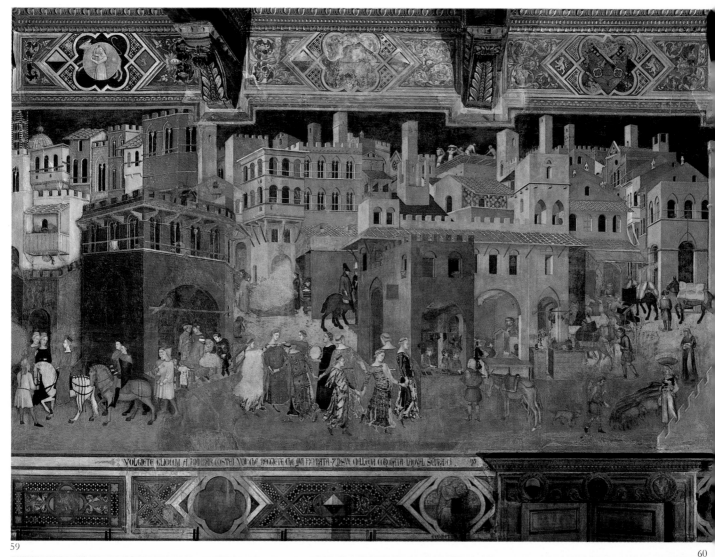

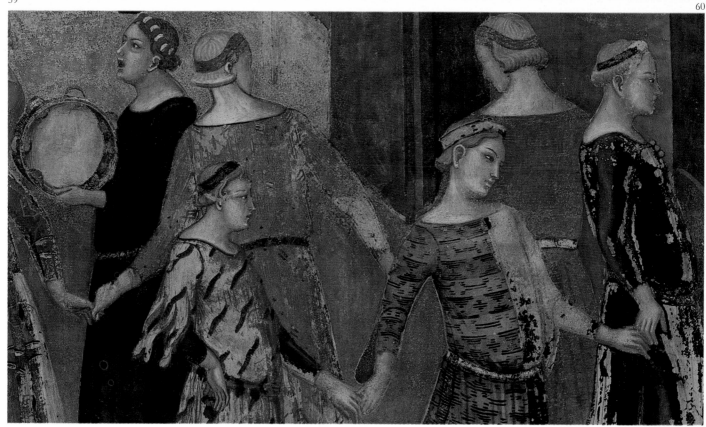

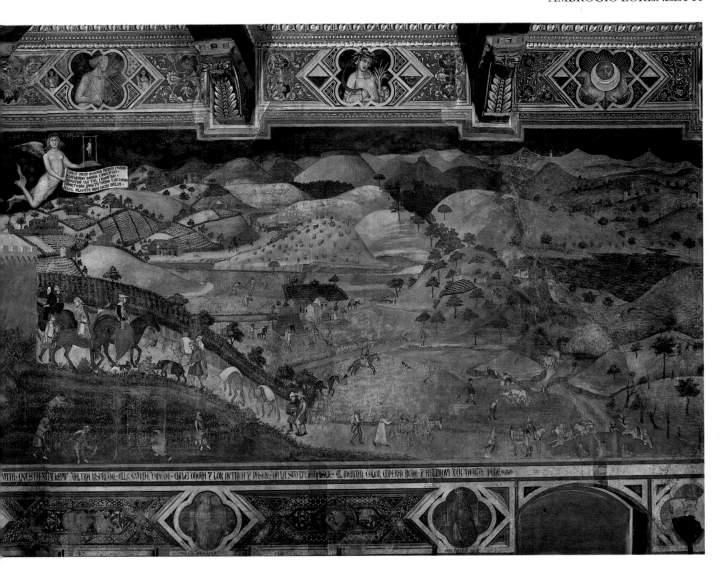

**Ambrogio Lorenzetti**
59. *Effects of Good Government.* Palazzo Pubblico.
60. *Effects of Good Government, detail.*

security of the State and keeping watch over a host of malefactors in chains.

The various Virtues are identified not only by inscriptions, but also by their traditional attributes. *Peace*, near the centre of the composition and evidently inspired by ancient sculpture, is gently reclining and bearing an olive branch, while treading swords and shields beneath her feet. This is the most beautiful figure in the whole cycle, on account of which the room is also called the "Sala della Pace" or Hall of Peace. *Concord* holds a large carpenter's plane on her knees, a symbol of the equality of all citizens in the eyes of the state. The two groups of allegorical personifications and historical characters are linked by a broad and majestic eliptical movement that confers unity on the whole vast composition.

The *Effects of Good Government* cover the whole of the right-hand wall, to a length of 14 metres. On the left is the well-governed city, a grandiose scenario of many-coloured buildings, giving us a panorama of 14th-century Siena with the Cathedral and its bell-tower, the squares and streets thronged with citizens, merchants and dancing girls (the "musical concord" of the dance is symbolic of the good relations existing between citizens), and the warehouses and loggias with builders at work on the roofs. The city and the surrounding landscape are linked by the great gateway in the city walls, through which a happy party of huntsmen is making its way out, passing the peasants coming into town to sell their wares. To the right is a vast open view of the Sienese countryside, with fields, vineyards and woods and large areas of bare rolling hills characteristic of the region. This whole scene is extended upwards in perspective until it nearly touches the very top of the fresco. The landscape is dotted with castles and farmhouses and farmers going about their work, while above is the figure of *Securitas* holding a gallows and hanged man as a warning.

On the opposite wall, the *Allegories* and *Effects of Bad Government* (unfortunately very fragmentary and in bad repair) form an exact contrast of ideas and techniques. The diabolic figure of *Bad Government* is surrounded by vices, while at his feet is *Justice* reviled and in fetters, while in the city, among crumbling buildings, are scenes of robbery and violence, and from the city gate a sinister party of armed men is setting out into the desolate countryside. But we have here given only a few of the many symbolic and "doctrinal" details and subtleties contained in this cycle of frescoes. And most impressive of all is the fact that out of such complex, intellectual and basically arid themes and materials Ambrogio has suceeded in giving us a masterpiece of extraordinary immediacy of expression and stylistic excellence.

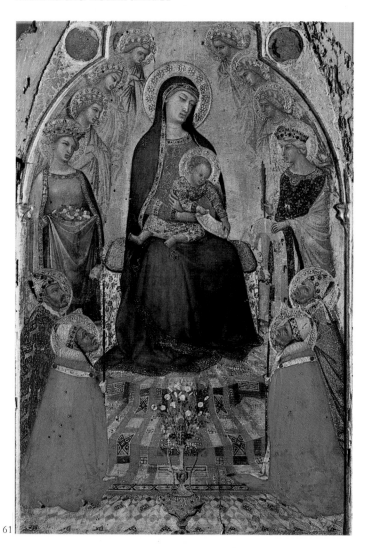

61

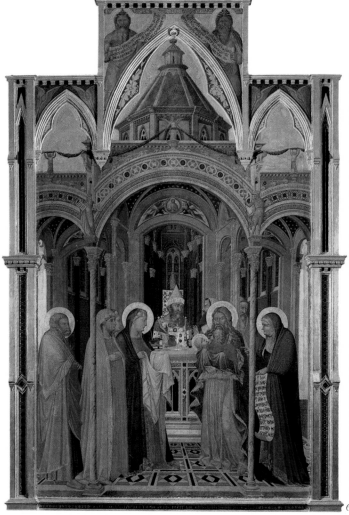

6

Ambrogio may still have been working on this great cycle of frescoes when in 1339 he started work on an altarpiece for the Cathedral completed in 1342. Now in the Uffizi, it depicts the *Presentation in the Temple*, against a background in which an almost fantasmagorical series of vaulted arcades and polychrome columns, and the checkered floor seen in perspective, give the scene enormous depth and set the altar off in the far distance. His work with perspective, one of the most important features of Ambrogio's idiom, did in fact grow increasingly intense and precise in his later period. Dating from about 1340 is the small *Maestà* (no. 65 in the Pinacoteca), one of the most remarkable creations of the entire 14th century, in which however the two lines of perspective formed by the design of the floor and the carpet beneath the throne of the Madonna converge on two different points one above the other, thus creating a double effect of spacial depth that enhances the image of the Madonna, bringing her nearer to the viewer after having already set her apart from the foreground clearly marked by the vase of flowers. The poetic and religious, as opposed to realistic, values taken on by the perspective in Ambrogio's painting seem to be confirmed by the *Annunciation* painted by him in 1344 for the Magistrates of the "Biccherna" (no. 88 in the Pinacoteca). The perspective lines of the vast pavement here converge upon a single central point, but the flow of these, rather than leading to a concrete spatial boundary, such as a wall for instance, is arrested by the abstract gold background. Nor should we neglect the originality with which the painter has interpreted this sacred event, replacing the traditional fear or humility on the part of the Madonna in the face of the Angel's message with an awareness and acceptance of the divine messenger, evident from the way she gazes serenely at the image of God the Father painted in monochrome on gold in the triangle between the two arcades above.

Ambrogio is also the author of two small pictures that constitute something unique in 14th-century painting. These are nos. 70 and 71 in the Pinacoteca of Siena, and depict a *Town by the Sea* and a *Castle on the Shore of a Lake*. Recent research has ascertained that these are not fragments of larger compositions, but two "pure landscapes" that probably show places in the ancient State of Siena: the town looks as if it might be Talamone, a port south of Grosseto. Along with other pieces now lost, these must have once adorned a wardrobe or a chest containing documents relating to those places, rather like the paintings on the covers of the account-books of the "Biccherna" and the "Gabella." But whatever practical purpose they served, which was certainly not a religious one, as we can see from the naked bather in one corner of them, we cannot escape the enchantment that pervades the crystalline volumes of the town bristling with towers and tight within its walls on a bare promontory over a blue sea, and the intense solitude of the small boat moored at the edge of the lake.

Finally, it is a lost work of Ambrogio's that gave its name to the largest hall in the Palazzo Pubblico of Siena, the "Sala del Mappamondo." At one time this room contained a huge map of the world, mounted on a turntable and probably done on parchment, with Italy in the middle. It was painted by Lorenzetti, and even in the 18th century a few tattered remnants of it could still be seen. Among the other masterpieces of this artist, who probably shared the fate of his brother Pietro in the great plague of 1348, we should at least mention the gloriously triumphant *Maestà* now in the Municipal Palace of Massa Marittima, the *Madonna and Child with Eight Saints* frescoed in a chapel in the church of Sant'Agostino in Siena, the triptych from Santa Petronilla (no. 77), and the *Madonna di Rapolano* (no. 605 in the Pinacoteca of Siena).

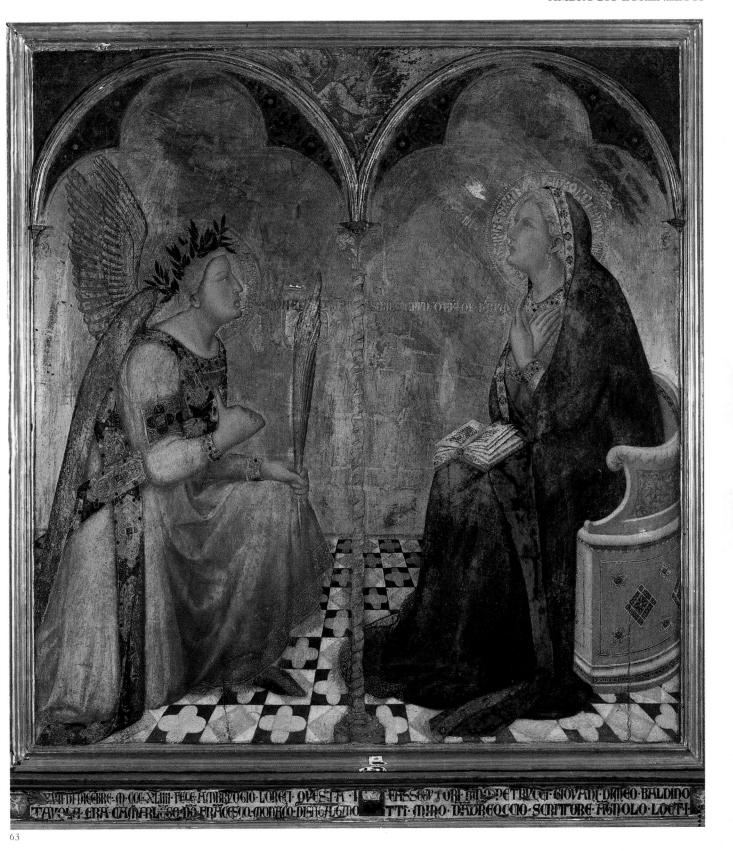

63

**Ambrogio Lorenzetti**

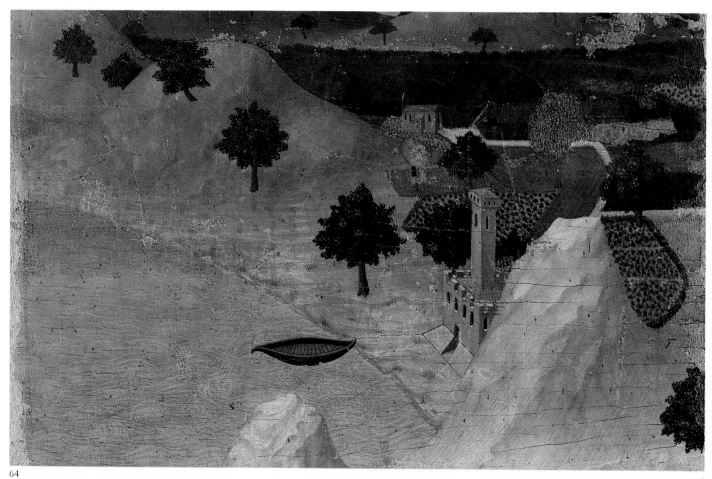

64

65

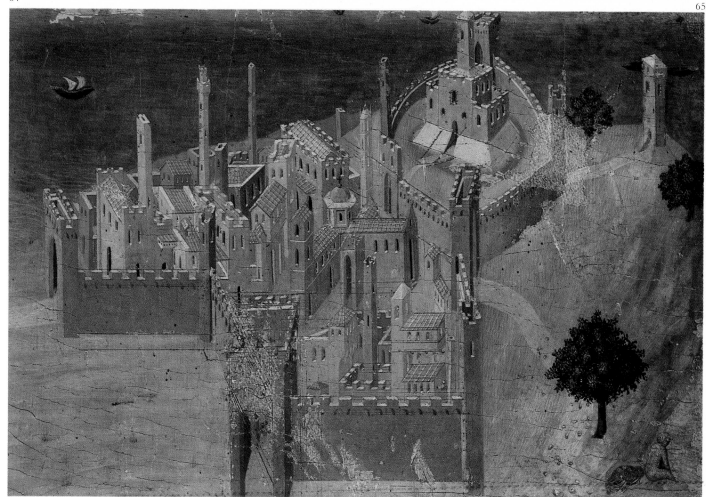

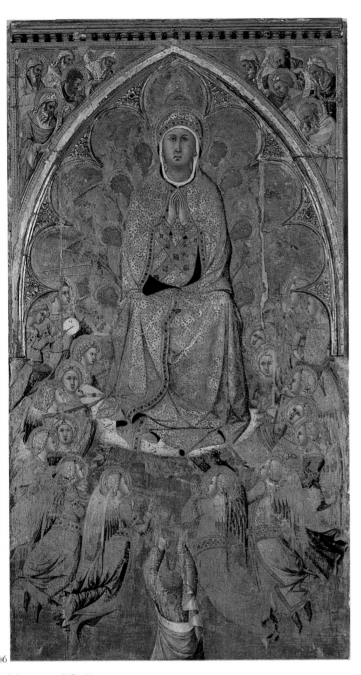

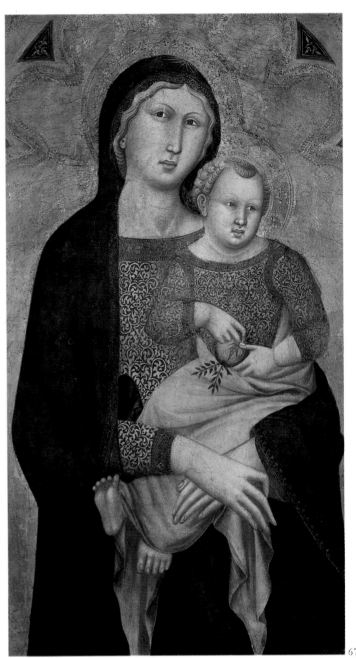

**Maestro d'Ovile**
66. *Assumption of the Virgin*. Pinacoteca.

**Niccolò di Ser Sozzo**
67. *Madonna*. Florence, Uffizi.

The major Sienese painters of the 14th century are all (with some doubt about "Barna") fairly well identified and documented, except for one very interesting artist whom Berenson in 1917 called **"Ugolino Lorenzetti,"** because in his work, to varying degrees, he reflects and compounds elements derived from Ugolino di Nerio and Pietro Lorenzetti. The works attributed to him are a polyptych in the Santa Croce Museum in Florence, the triptychs of Fogliano and Sestano, now in the Pinacoteca numbered 42 and 43, and a number of others. However, recent research tends to credit him also with various anonymous works that, because they had points of style in common with a *Madonna* in the church of San Pietro a Ovile in Siena, were attributed to one **"Maestro d'Ovile."** And the fact that there is a certain link with a *Nativity* in the Fogg Museum in Cambridge, Massachussetts would seem to indicate that these may belong to a later phase in the career of "Ugolino Lorenzetti," who also would in this case have come under the influence of Simone Martini.

The masterpiece of this painter (whom some rather boldly identify with one Bartolomeo Bulgarini, but according to a more recent hypothesis, his work is more likely to have been the product of a workshop active from about 1330 to 1350-60), is a panel showing the *Assumption*, formerly in the Spedale di Santa Maria della Scala and now in the Pinacoteca (no. 61), a work that glows with engraved gold to such an extent that even in the painted parts it seems more the product of some prodigious goldsmith than of a painter.

The *Assumption of the Virgin* was a theme fairly often treated by Sienese painters of the 14th and 15th centuries. One of the earliest, and maybe one of the finest as well, is a large miniature that acts as the frontispiece of a manuscript in the State Archives. It was painted in about 1336 by **Niccolò di Ser Sozzo di Stefano** (once wrongly thought to be a member of the Tegliacci family), a miniaturist and painter influenced somewhat by Pietro Lorenzetti and Lippo Memmi, to whom we owe numerous manuscripts illuminated either by him or in his flourishing workshop, and also several paintings including a polyptych in the Museum of San Gimignano and the truly gorgeous one numbered 51 in the Pinacoteca of Siena, done in 1362 in collaboration with **Luca di Tommè**.

Luca di Tommè, mentioned in documents up to 1389, did a lot of work outside the territory of Siena. An austere *Crucifix* in the Pisa

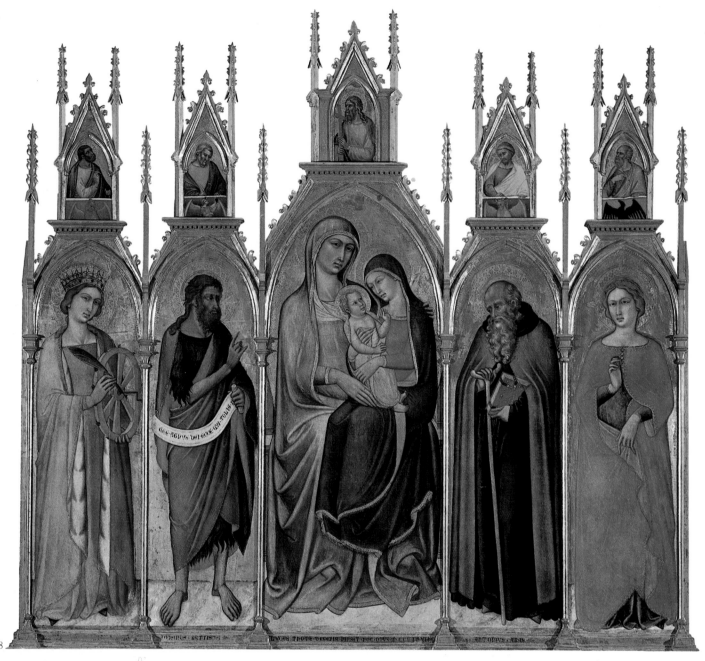

68

Museum bears his signature and the date 1366, and is plainly influenced by Pietro Lorenzetti; a polyptych in the art gallery at Rieti is dated 1370. Others of his works are found at Foligno and Mercatello delle Marche, while his art had an important effect on the early career of the major painter of Orvieto, Ugolino di Ilario. The list of his works is vast, and apart from several minor works the Pinacoteca has three polyptychs attributed to him, the best of which is numbered 109. It is signed and dated 1367, and comes from the Capucin monastery at San Quirico d'Orcia. In the central panels is the popular figure of "Sant'Anna Metterza," or St. Anne with the Virgin and Child on her lap.

Another painter who did a lot of work outside Siena was **Lippo Vanni**, who according to recent critics was in Naples in 1342-43, and subsequently received commissions from churches in Rome and Perugia. Documented from 1341 on, he was an exquisite miniaturist rather in the manner of Lorenzetti and a fine fresco-painter. In 1373 he did the great monochrome fresco of the *Battle of Val di Chiana* in the "Sala del Mappamondo" of the Palazzo Pubblico in Siena, but rather than in this somewhat laboured composition his genuine talents are revealed in the frescoed polyptych in the ex-Seminary at Siena and above all in the decoration of the Choir of the Augustinian church of San Leonardo al Lago (c. 1360-70), with its musician angels

on the ceiling and *Stories of the Virgin* on the walls. In these we see him as the most talented follower of Pietro Lorenzetti as far as the use of space and perspective is concerned.

Among the others who continued and diffused the manner of the Lorenzetti brothers we should mention **Jacopo di Mino del Pelicciaio**, first documented in 1342 and who died some time before 1396. In 1362 he put his signature to a large polyptych showing the *Coronation of St. Catherine of Alexandria*, formerly in the church of Sant'Antonio in Fontebranda, and now in the Pinacoteca numbered 145. However his masterpiece is a really wonderful *Coronation of the Virgin* in the museum at Montepulciano. Another artist worthy of mention is **Paolo di Giovanni Fei** (born around 1344, died in 1411), who in 1398 for one of the altars in the Cathedral of Siena made an altarpiece showing *The Presentation of Mary in the Temple*, now in the National Gallery in Washington, in which the architectural features recall those of Ambrogio Lorenzetti's work on the same theme in the Uffizi. Pietro Lorenzetti's *Nativity of the Virgin* was evidently the inspiration for the altarpiece in the Pinacoteca of Siena (no. 116); this artist did not understand the grave and sacred character of that work, but gives us a delightful scene from everyday life, rich in pleasing details and clear enamelled colours.

The second half of the 14th century in Siena saw a vast

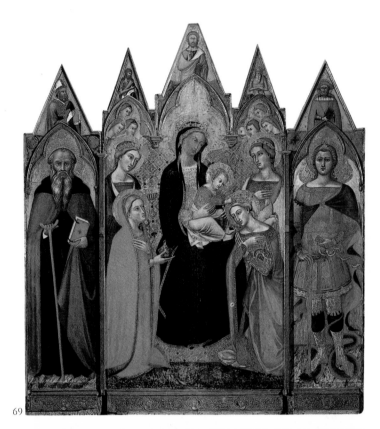

**Luca di Tommè**
68. *"Sant'Anna Metterza."* Pinacoteca.

**Jacopo di Mino del Pellicciaio**
69. *Coronation of St. Catherine of Alexandria.* Pinacoteca.

**Lippo Vanni**
70. *Presentation of Mary in the Temple.* San Leonardo al Lago.
71. *Marriage of the Virgin.* San Leonardo al Lago.

69

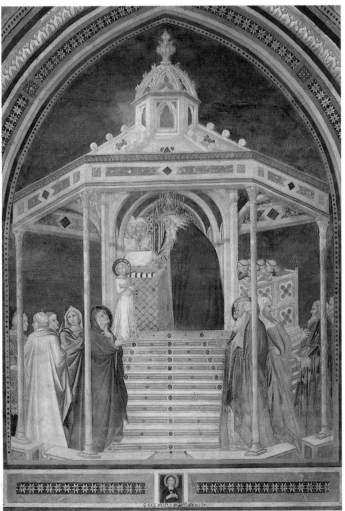

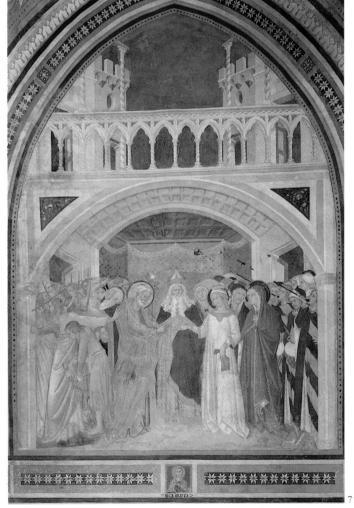

71

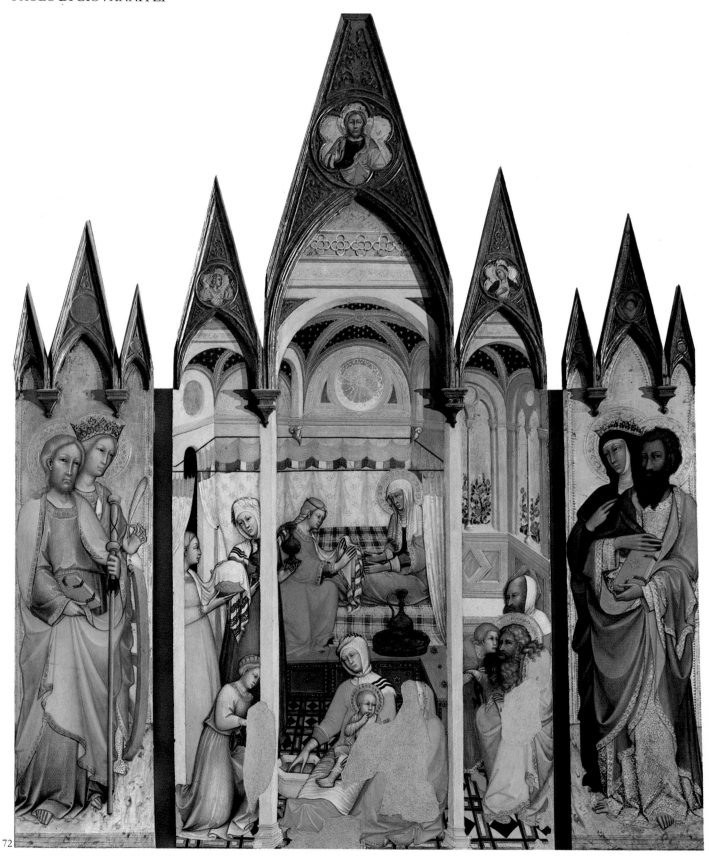

72

production of altar-frontals, diptychs, triptychs and small altarpieces in general, often finely engraved. These works were usually intended for domestic use, and outstanding among the artists concerned were **Niccolò di Bonaccorso, Francesco di Vannuccio** and **Naddo Ceccarelli**, the last of whom was more influenced by Simone Martini and his circle than by the Lorenzetti style. And in fact Simone's influence increasingly prevailed over that of the Lorenzetti from the 1370s on, and recent studies have tended to put this down to the

mediating role played by Donato Martini, Simone's brother who outlived him, even if no work of his is known for sure to have survived.

**Bartolo di Fredi**, however, worked very much in the manner of Simone's followers when in 1353 he had a workshop in conjunction with **Andrea Vanni** (who went on into the 15th century, using the style of Simone in a rather wooden manner, though he was responsible for the famous portrait of *St. Catherine of Siena* in

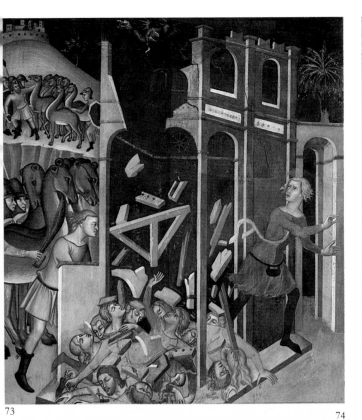

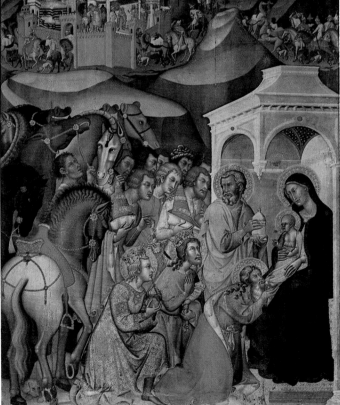

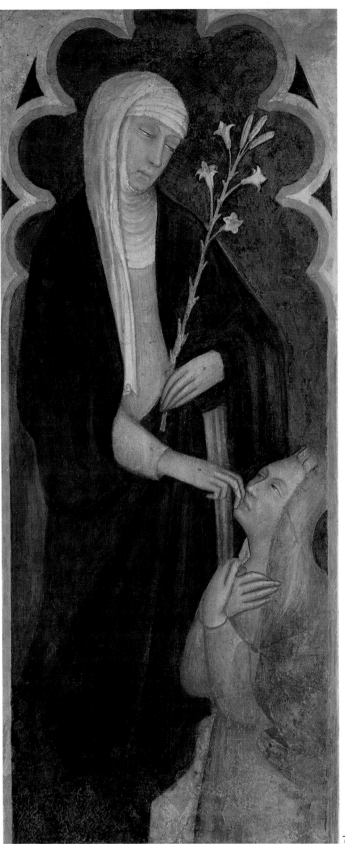

**Paolo di Giovanni Fei**
72. *Nativity of the Virgin.* Pinacoteca.

**Bartolo di Fredi**
73. *Earthquake in the House of Job.* San Gimignano, Collegiate Church.
74. *Adoration of the Magi.* Pinacoteca.

**Andrea Vanni**
75. *St. Catherine of Siena.* Basilica of San Domenico.

the Basilica of San Domenico), but in the *Stories from the Old Testament* that Bartolo painted in 1367 in the Collegiate Church of San Gimignano he attempted, in the words of De Benedictis, "an up-dating and revision of the Lorenzetti spatial system," without however really grasping their rigour of thought and poetic quality. Bartolo di Fredi, who probably died in 1410, was an eclectic and rather fragmentary artist, though when he did not fall into rigid conventional formulas he was capable of using gay and limpid colours

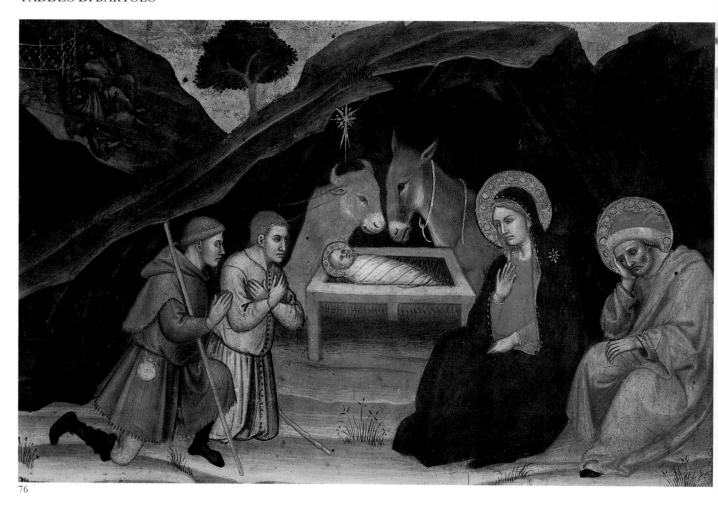

76

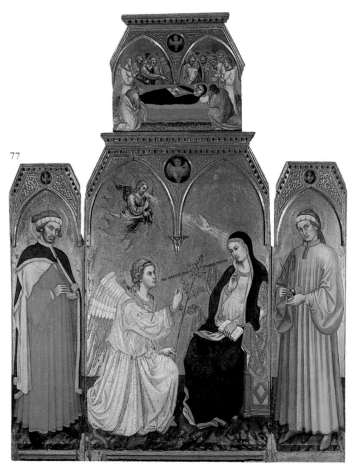

77

**Taddeo di Bartolo**
76. *Adoration of the Shepherds.* Pinacoteca.
77. *Annunciation.* Pinacoteca.

and of displaying considerable narrative verve, as for example in the *Adoration of the Magi* (no. 104 in the Pinacoteca), the whole of which is immersed in an atmosphere of fairy-tale splendour.

Of more modest talent was his son **Andrea di Bartolo**, who after following the style of his father passed on to the imitation of that of **Taddeo di Bartolo**. The latter (born 1362, died 1422) was the outstanding artist working at the turn of the century. Active in Pisa, Volterra, Umbria and Liguria, he spread and exemplified the taste for Sienese art, following in the great Lorenzetti tradition, in the manner of a solid conservative endowed with exceptional technique. His best work in fresco in Siena was the decoration of the chapel in the Palazzo Pubblico, showing *Stories of the Life of the Virgin*, painted between 1406 and 1409, to which in 1414 he added a series of *Famous Men of Antiquity* in the ante-chapel. To him we owe the largest painting on wood of the entire Sienese school, the polyptych of the *Assumption* done in 1401 for the Cathedral of Montepulciano. Also very large and one of his best works is the triptych of the *Annunciation* (no. 131 in the Pinacoteca); the three panels in the same gallery, showing the *Epiphany* (no. 127), the *Adoration of the Shepherds* (no. 132) and the *Martyrdom of Saints Cosmas and Damian* (no. 134), with their simple and restrained composition that approaches the archaic, were originally part of the predella of this work. Under his influence to a greater or lesser extent were his adopted son **Gregorio di Cecco di Luca**, **Benedetto di Bindo** and **Martino di Bartolomeo**, the last of whom (d. 1434) may be considered the very last heir of the 14th-century tradition.

# The 15th Century

A wind of change and a more complex type of culture entered Sienese painting with the polyptych done in 1423-26 for the "Arte della Lana" (the Wool Guild). The artist was **Stefano di Giovanni**, later to be known as **Sassetta**. All that remains of this work consists of a side-panel in the collection of the Monte dei Paschi Bank in Siena, the predella now distributed among the Pinacoteca (nos. 166 and 167), the Budapest Museum, the Vatican Pinacoteca, the Bowes Museum at Barnard Castle and the Museum of Melbourne, along with a few other minor but significant fragments. Sassetta, whose date of birth is unknown, here shows that he was in touch with all the most recent tendencies of European late-Gothic (which probably came to him by way of the exquisite painting of Masolino da Panicale), while at the same time he went further with the Lorenzetti's intuitions of space, adding realistic features unknown to the previous tradition.

Thus, for example, in the *St. Antony Beaten by Devils* (one of the panels of the above-mentioned predella), the depth and articulation of the landscape is for the first time seen against a blue sky streaked with white clouds, instead of the customary gold background. In the *Adoration of the Magi* in the Chigi Saracini Collection in Siena, a fragment of a larger composition which included the *Journey of the Magi* in the Griggs Collection in New York, we clearly see that Sassetta was greatly attracted by the art of Gentile da Fabriano, who spent some time in Siena in 1425 and 1426. But it is with the great altar-frontal of the *Madonna della Neve*, painted in 1430-32 for the Cathedral of Siena and now in the Contini Bonacossi Foundation (Uffizi), that he clearly shows how far he adhered to the "great Florentine concepts of form in perspective" (Graziani), even if these do not have much effect on the composition, but rather tend to stimulate occasional brilliant innovations.

Echoes of Masaccio and Paolo Uccello can be seen in the great *Crucifix* painted (probably in 1433) for the church of San Martino in Siena, some fragments of which are in the Chigi Saracini Collection, and in the polyptych of the church of San Domenico at Cortona. These are works that herald the condensed and yet vibrant sculptural precision of this painter's later style. This precision is represented by the great polyptych painted on both sides on which the artist worked from 1437 to 1444 for the Franciscan church of Borgo San Sepolcro, and which was dismembered at the beginning of the last century. On the front were the *Madonna and Child with Six Musician Angels*, the *Blessed Ranieri Rasini*, *St. Antony of Padua*, *St. John the Baptist* and *St. John the Evangelist*, while on the back was *St. Francis in Ecstasy* flanked by eight *Episodes from the Life of the Saint*. It also had a predella.

The work is now distributed between the Louvre, the Berenson Collection at Settignano, the National Gallery in London, the Musée Condé at Chantilly, and the State Museums in Berlin, while four panels from the predella are either lost or unidentified. It is Sassetta's masterpiece and a work of capital importance for Sienese painting in the 15th century, since it incorporates and assimilates hints and features from an extremely wide-ranging culture; but at the same time it is the quintessence of a civilization that was clearly and unmistakably local, and that uniquely combined subtle intellectualism with "primitive" candour.

Particularly memorable is the image of *St. Francis in Ecstasy*, firm and monumental in its construction, in which the saint is seen as a "second Christ." The eight *Episodes* are also remarkable for their rigour of composition, narrative effect and fine colouring. While working on a huge *Coronation of the Virgin* in fresco above the gate of Porta Romana in Siena, the painter caught pneumonia and died of it on April 1st, 1450. The fresco was completed by Sano di Pietro, but was almost entirely destroyed during the war in 1944.

In 1940 the critic Roberto Longhi realized that it was difficult to find a place in the development of Sassetta's style for the triptych showing the *Madonna and Child between St. Jerome and St. Ambrose* in the Basilica dell'Osservanza in Siena. The work was traditionally attributed to him, and bears the date 1436, but because it is still highly Gothic in style he could not possibly have painted it after the *Madonna della Neve*, finished in 1432. We therefore have to attribute this triptych, along with other similar works thought to be by Sassetta, to some other painter, who was probably an assistant of his but inclined towards more archaic forms. The figure of an anonymous painter thereupon began to take on life, and because of this triptych he is known as the "**Maestro dell'Osservanza.**" He probably collaborated with Sassetta on eight charming panels dealing with *Stories of St. Antony Abbot*, now distributed among the museums of Berlin, Washington, New Haven, New York, and the Lehman Collection in New York. After 1436 the same master painted the famous altarpiece showing the *Nativity of the Virgin*, formerly in the Collegiate Church and now in the Museum of Sacred Art in Asciano. Here we may note the influence of Domenico di Bartolo, while Sassetta's solidity of form is replaced by more two-dimensional solutions, though still very beautiful.

Some critics have attributed the work of this gentle painter to the early period of **Sano di Pietro**, who although born in 1406 and enrolled as a painter in 1428 only begins to be known to us in 1444, when he signed and dated the great *Polyptych of the Gesuati* (no. 246 in the Pinacoteca of Siena, though the predella with the *Stories of St. Jerome* was taken to Paris in 1812 and is now in the Louvre).

Although this is a work of very high quality, possibly Sano's masterpiece, and very closely connected to the work of the "Maestro dell'Osservanza," nonetheless the figures are conceived in a rather different way: the light and shade contrast is more forceful, while the profiles and outlines, which the "Maestro dell'Osservanza" tends to fade into his luminous planes of colour, are here both clearer and more rigid. Certainly after the *Polyptych of the Gesuati* – so called because the figure kneeling at the Madonna's feet is the Blessed Giovanni Colombini, founder of the Gesuati, from whose monastery of St. Jerome the painting originally came – Sano di Pietro's style tended increasingly towards formulas that were often stereotyped, and continued in this way right up to 1481, the date of the artist's last painting and death.

He left us countless paintings, including magnificent colourful polyptychs, altarpieces and small panels, in which with few variations we get the image of a Madonna with gentle and somewhat bovine eyes beneath highly arched eyebrows, wrapped in a blue cloak with sinuous Gothic swirls and holding a Christ Child with rosy cheeks and

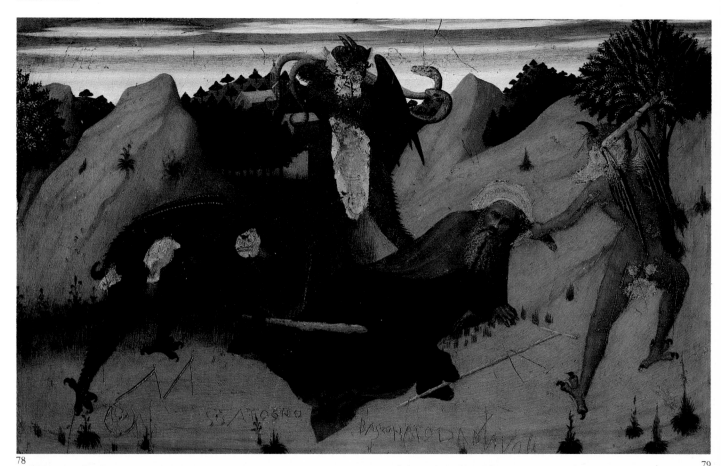

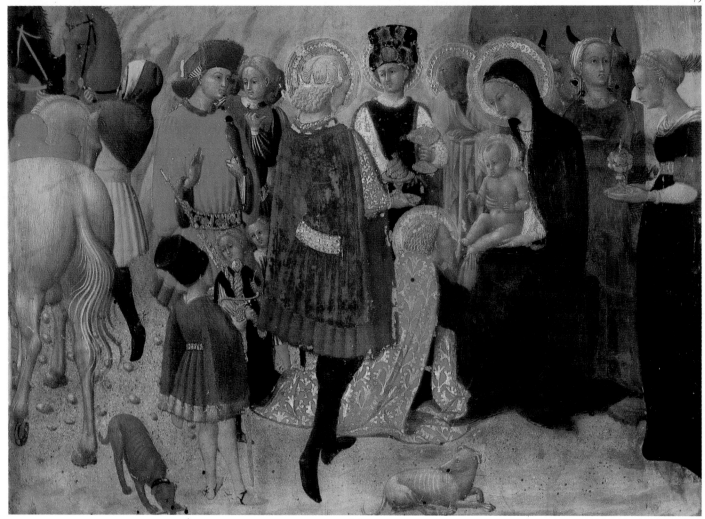

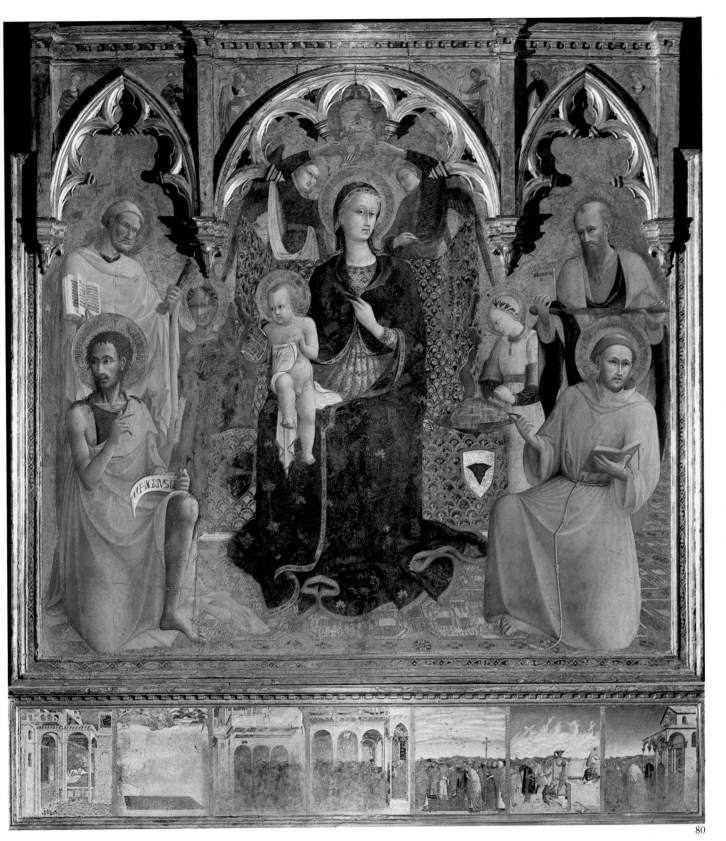

80

golden curls. But in all this copious production we have to distinguish what he did himself from the mass of work done wholly or in part in his workshop, bearing in mind his considerable talents as an illustrator, whether he was narrating the lives and miracles of saints or faithfully documenting the sermons of St. Bernardino in the Piazza del Campo or in front of the church of San Francesco, as he does in two really charming panels in the Chapter House in Siena. Nor should we neglect that "primitive" ingenuity expressed in the *Madonna and Pope Callixtus III* on a large votive tablet (dated 1456) in the Pinacoteca of Siena (no. 241).

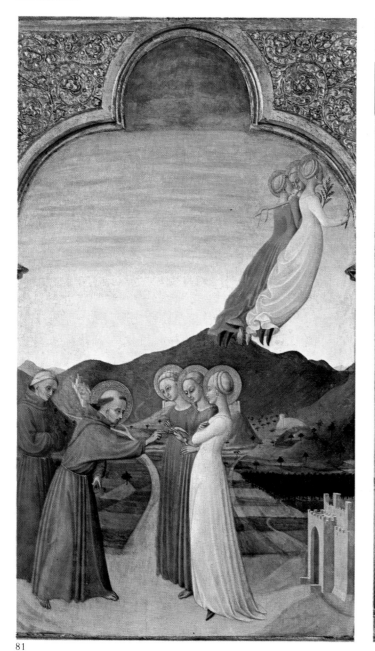

81

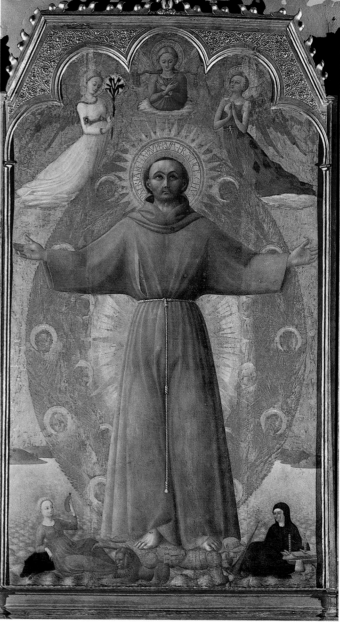

82

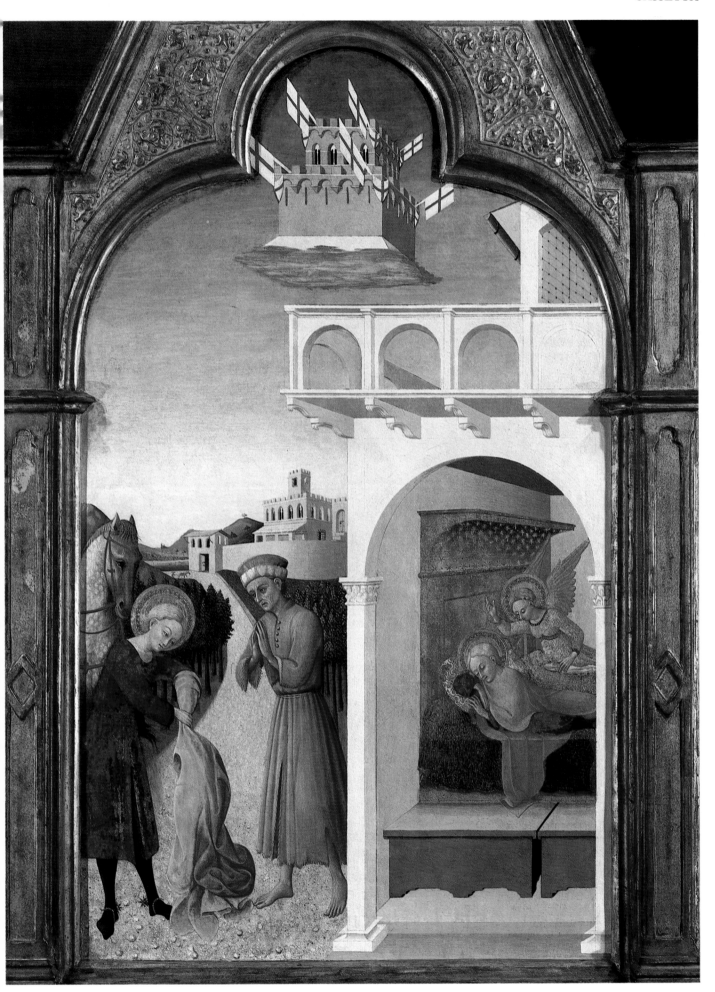

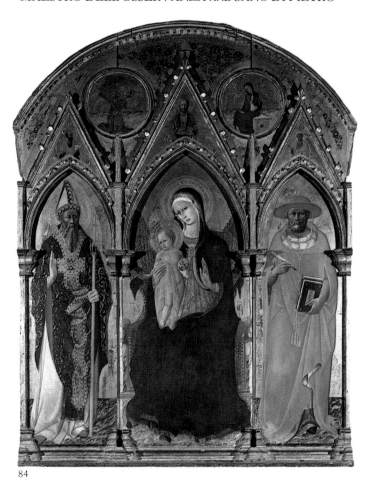

84

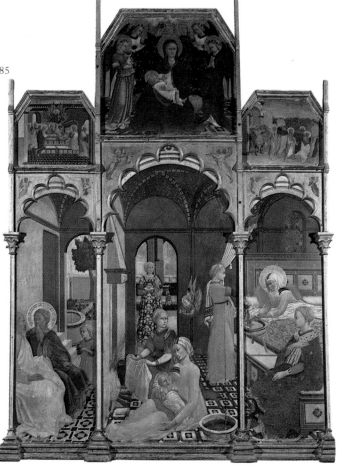

85

**Maestro dell'Osservanza**
84. *Madonna and Child between St. Jerome and St. Ambrose.* Basilica dell'Osservanza.
85. *Nativity of the Virgin.* Asciano, Museum of Sacred Art.

**Sano di Pietro**
86. *Sermon of St. Bernardino in front of the church of San Francesco in Siena.* Chapter House.
87. *Polyptych of the Gesuati.* Pinacoteca.

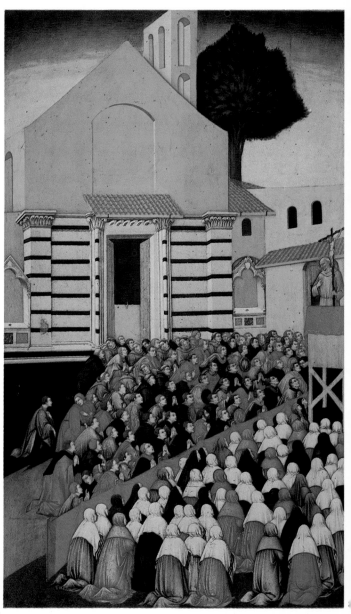

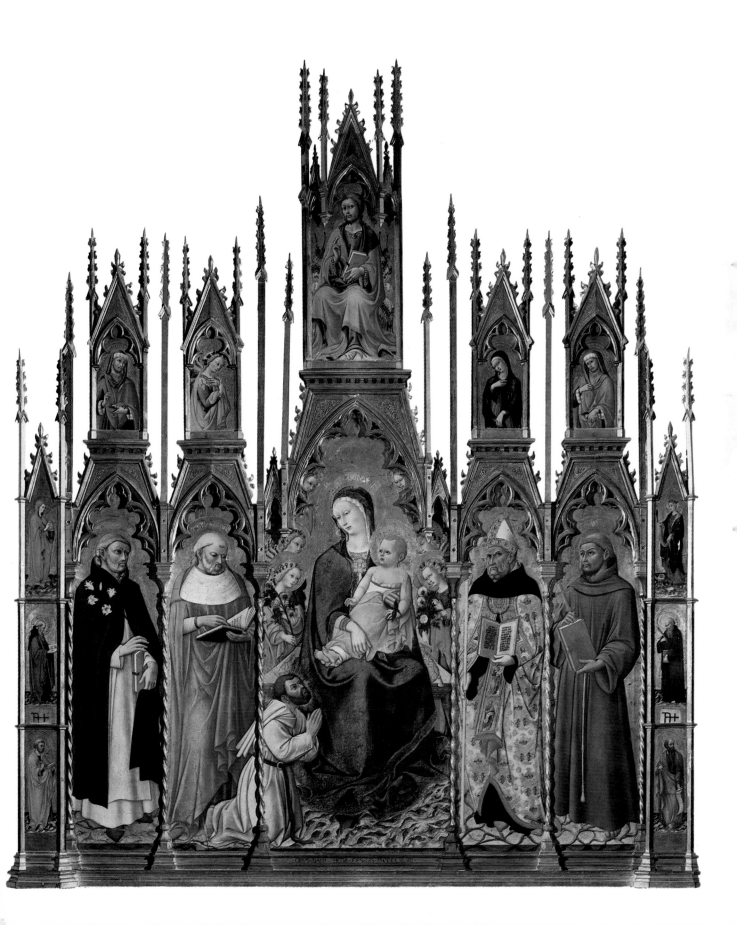

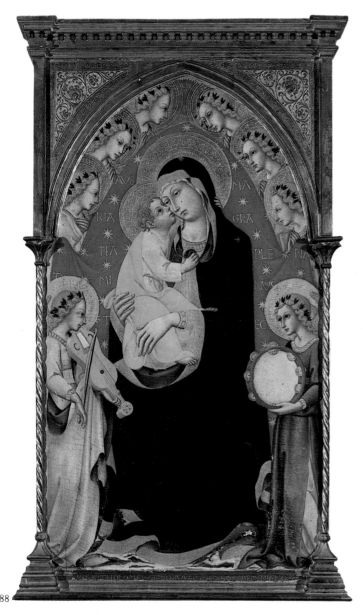

88

Sano di Pietro

**Sano di Pietro**
88. *Madonna and Child*. Pinacoteca.
89. *Madonna and Pope Callixtus III*. Pinacoteca.

**Giovanni di Paolo**
90. *Christ Suffering and Christ Triumphant*. Pinacoteca.

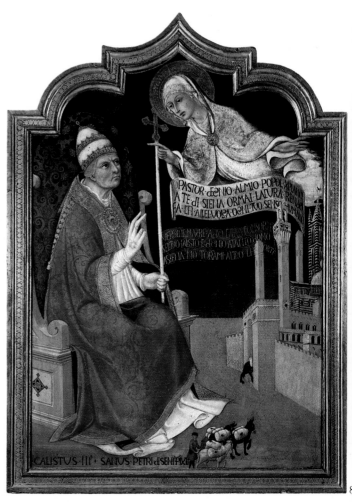

A painter whose career ran parallel with that of Sano di Pietro is **Giovanni di Paolo** (1399-1482), the other representative of the "conservative" tendency in Sienese painting of the 15th century. While we see some influence of Gentile da Fabriano, who as we said was working in Siena in 1426, the style of this artist is basically immune from outside cultural influences; he develops from the local Gothic tradition an unmistakable impetuous linear art, sometimes very taut and precise, but more often exuberant to the point of positively manneristic tortuosity. It is a use of line that with its nervous incisiveness boldly deforms the very data of reality, projecting them onto a plane of fantasy and abstraction.

Like Sano di Pietro, he produced a mass of altarpieces and polyptychs, retaining to the very end the Gothic structures and gold background. Among his earliest works is a panel showing *Christ Suffering and Christ Triumphant* (no. 212 in the Pinacoteca), characterized by the rather archaic and almost 13th-century style of the second, and by the harrowed profile of the Christ Suffering, witness to a genuine dramatic feeling that becomes intensely tragic in the *Crucifixions* on wood in the Lanckoronski Collection in Vienna and in the Siena Pinacoteca (no. 200), as well as in the unfortunately damaged monochrome painting at San Leonardo al Lago (c. 1445), which is the only known fresco by this artist.

However, like Sano di Pietro, he was also an excellent miniaturist, the author of ten very fine *Stories of the Baptist* now all in collections and museums abroad, that are entitled to be called his

masterpiece on account of the magic that radiates from the imaginary buildings and the landscapes that take on the air of fairy-tales. Another cycle of small paintings, also dispersed throughout numerous foreign museums, is the one of the *Stories of St. Catherine of Siena* that once surrounded the altarpiece of the *Presentation of Mary in the Temple*, painted in 1447-49 for the Corporation of "Pizzicaioli" and now in the Pinacoteca (no. 211). It is clearly inspired by the work on this theme by Ambrogio Lorenzetti, and belonging to the same style is the charming *Madonna dell'Umiltà* (no. 206), with its archaic stylized landscape with a horizon arched as if to echo the curvature of the Madonna's halo. She herself is seen against a dense copse of trees with flowers and fruits, which we will find again in the Paradise of the later predella showing the *Last Judgment* (no. 172 in the Pinacoteca). The care with which in this and other paintings the artist observed the minute details of the plant world is a feature that links him with International Gothic.

Starting in 1462, the year in which he made an altarpiece for the Cathedral of Pienza, the artist began to display a darkly expressionistic tendency, with hard and contorted lines that rendered the features of his characters scarcely short of grotesque, and marked a slow decline of his idiom, increasingly isolated from the living currents of his time.

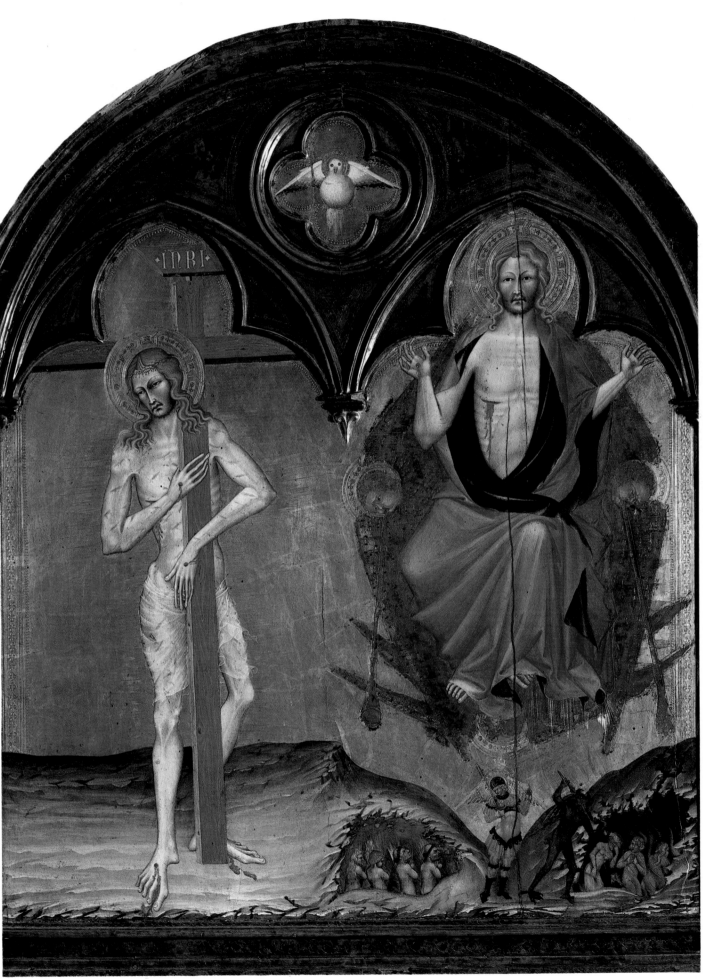

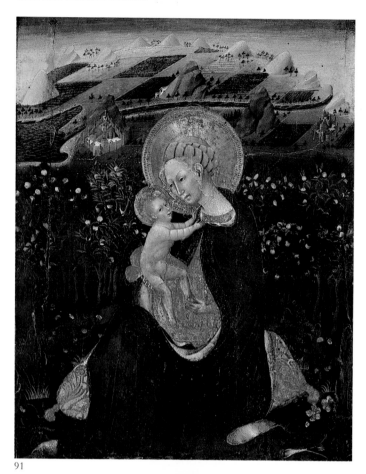

91

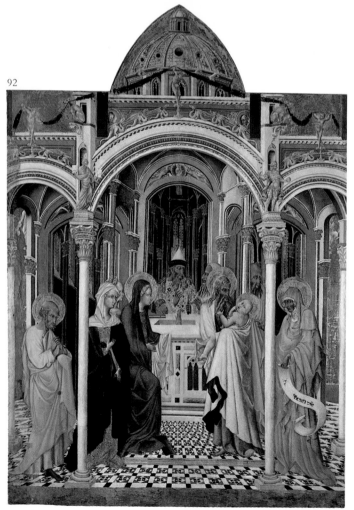

92

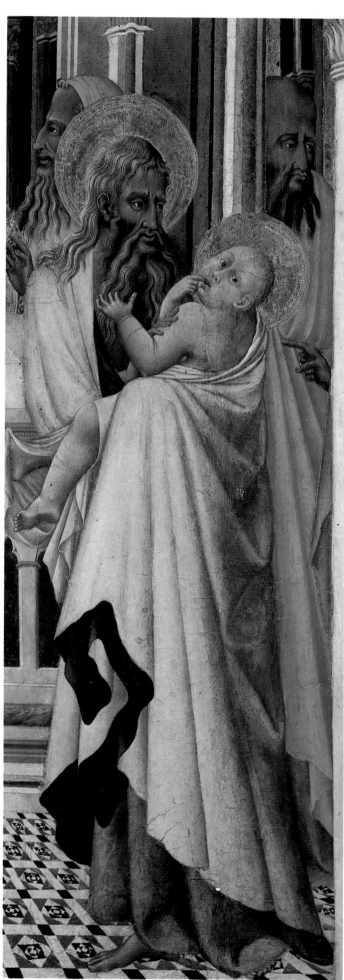

93

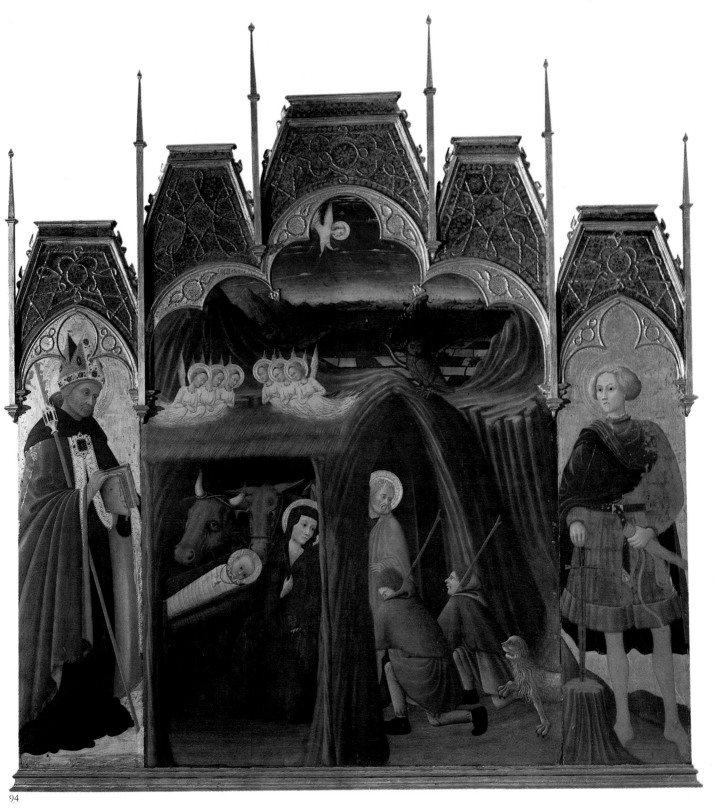

94

**Giovanni di Paolo**

91. *Madonna dell'Umiltà*. Pinacoteca.
92. *Presentation in the Temple*. Pinacoteca.
93. *Presentation in the Temple, detail*.

**Pietro di Giovanni**

94. *Nativity*. Asciano, Museum of Sacred Art.

On the other hand a painter eager to assimilate the things being done in Florence by Masaccio, Paolo Uccello and Fra Angelico was **Pietro di Giovanni d'Ambrogio** (1410-1449), whose short life prevented him from becoming one of the outstanding figures in 15th-century Sienese painting. We see his talents in a banner (1444) in the Jacquemart-André Museum in Paris, and in the many images of *St. Bernardino*, in which he gives us the features of this saint with an exactitude equal to the stylistic precision of the whole. And particularly precocious were the early works of **Domenico di Bartolo** (documented from 1428 to 1447), as we see them in the *Madonna dell'Umiltà* (dated 1433, no. 164 in the Pinacoteca), where personal interpretations of Masaccio, Donatello and Jacopo della

95

96

**Domenico di Bartolo**
95. *Madonna dell'Umiltà*. Pinacoteca.
96. *Madonna dell'Umiltà, detail.*

**Vecchietta**
97. *Annunciation.* Pienza, Museum.
98. *St. Bernardino.* Pinacoteca.
99. *Assumption.* Pienza, Cathedral.

Quercia are joined by a kind of diffused luminosity that seems almost a herald of Domenico Veneziano. This painting, in which the Madonna is surrounded by five musician angels, bears a scroll with a pious inscription in hexameters (the first to be found in Siena) which ends with the painter's signature formulated in these significant terms: DOMINICUS DOMINI MATREM TE PINXIT ET ORAT (Mother of God, Domenico painted you and prays to you). In 1438 he executed a polyptych for the monastery of Santa Giuliana at Perugia (now in the gallery there) that was destined to have considerable impact on Umbrian painting, and between 1440 and 1444 he worked on the fresco of the "Pellegrinaio" (pilgrims' quarters) of the Spedale di Santa Maria della Scala, the ancient hospital opposite the Cathedral in Siena. In illustrating the good works performed in the hospital the artist took a turn towards the Gothic style, producing a very lively and faithful picture of the customs of the time, with a wealth of detail and portraits. A number of very expressive portraits are also to be found in the fresco of the *Madonna del Manto*, painted in 1444 for the same hospital.

In 15th-century Siena the Spedale di Santa Maria della Scala commissioned more art than any other public body, even the Commune. In the "Pellegrinaio" we find the first documented work of **Lorenzo di Pietro**, known as "**Il Vecchietta**" (1410-1480). It is a fresco showing the *Legend of the Foundation of the Hospital* done in 1441 when the artist, recent critics think, had just come back from a period in Florence and at Castiglion d'Olona, where he had worked with

Masolino da Panicale on the frescoes in the Collegiate Church. The fresco in the hospital, dominated by an imposing if slightly cold architectural scene in perspective, has a wealth of Florentine details, reminiscences of Masaccio and Masolino. They are, however, rather superficial, and the artist gradually shed them, working with simpler structural forms enlivened by clear and delicate colouring. In the "arliquiera" or reliquary, painted in 1445 for the same hospital (now in the Pinacoteca, no. 204), the softened forms of the Saints are outlined with almost Gothic grace against the twining gold motifs of the background, while in the magnificent frescoes showing *Parallel Stories from the Old and New Testament* in the sacristy of the hospital, dating from 1446-49, the architectural repertoire of the Renaissance is transformed into a whole anthology of imaginative combinations of gay colours.

Another important cycle of frescoes by Vecchietta, even though rather over-restored, is the one showing the *Articles of Faith* (1450-53) on the ceiling of the Pieve di San Giovanni, while a lovely picture of *St. Catherine* frescoed in the Palazzo Pubblico dates from 1461. His paintings on panels are not many, but they are significant. Outstanding is the triptych of the *Assumption* done in about 1462 for the Cathedral of Pienza, which on account of the splendid figure of the Virgin towering above a ring of angels chanting hosannas may be considered the masterpiece of Vecchietta, who in signing this and other paintings called himself a sculptor; and indeed in sculpture he has few rivals in his century. He was, incidentally, also an architect,

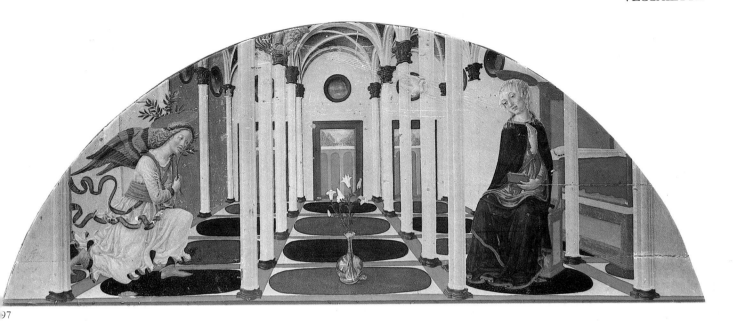

97
98
99

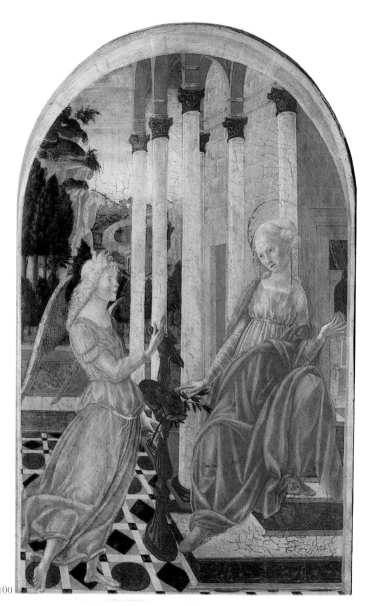

100

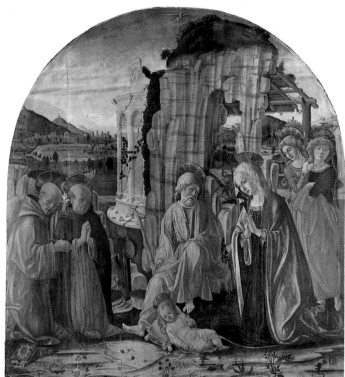

101

**Francesco di Giorgio Martini**
100. *Annunciation*. Pinacoteca.
101. *Nativity*. Pinacoteca.
102. *Nativity, detail*.
103. *Coronation of the Virgin*. Pinacoteca.

102

and quite a circle of painters, sculptors and architects formed around him, so that with the complex but entirely coherent development of his artistic idiom, and the depth and broad range of his culture, he occupies a key position in 15th-century Sienese art.

It is in fact in the context of Vecchietta that we find the earliest painting of **Francesco di Giorgio Martini** (1439-1502), whose versatility as architect, painter, sculptor, engineer and theorist makes him the incarnation of the loftiest ideals of the Renaissance. However, in two panels from a chest bearing *Stories of Joseph and Susanna* in the Siena Pinacoteca (nos. 274 and 275) the architectural elements are uncompromisingly classical, and other classical features are to be seen in various paintings such as the *Nativity* of 1475, formerly at Monteoliveto and now in the Pinacoteca (no. 437), and the *Annunciation* (no. 277 in the Pinacoteca).

This artist's whole culture must in fact have been greatly affected by his journey to Rome, probably during the pontificate of Pius II (1458-64), which gave him the opportunity to study ancient monuments, and to set down his observations in sketches and drawings, some of which have come down to us in two precious notebooks. In Francesco di Giorgio's painting these hints of humanism are united with an exact knowledge of the most recent trends in Florence, represented by Pollaiolo and Botticelli, Filippino Lippi and Verrocchio, while in his architecture and theoretical treatises he reveals one of the most modern and original minds of his century. In spite of this, in his painting he remained substantially faithful to the anti-realistic tradition of Siena, which rejected the

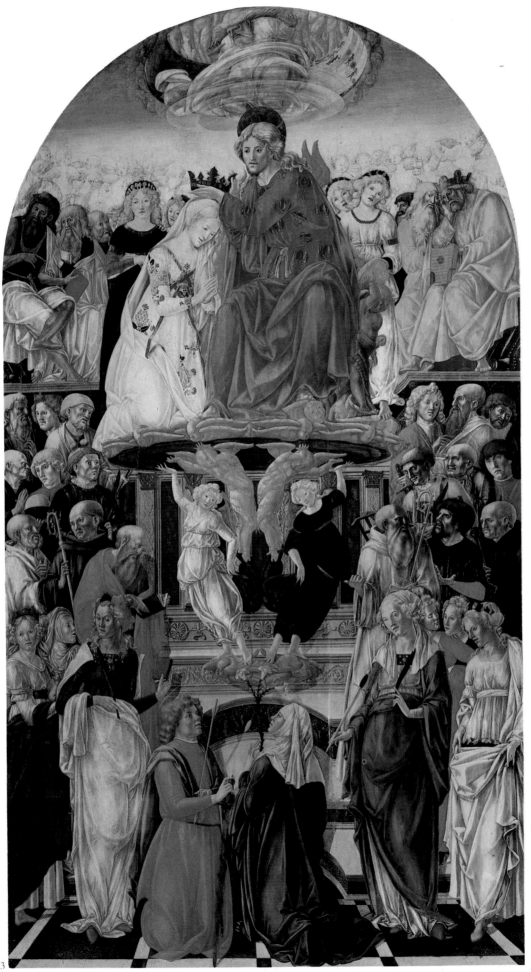

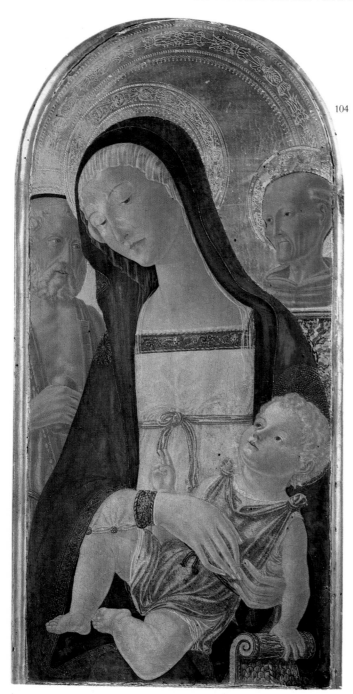

104

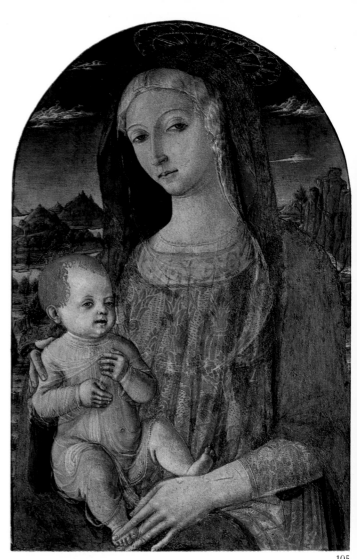

105

**Neroccio di Bartolomeo**
104. *Madonna*. Pinacoteca.

**Matteo di Giovanni**
105. *Madonna and Child*. Pinacoteca
106. *Slaughter of the Innocents*. Church of Sant'Agostino.
107. *Polyptych*. Asciano, Museum of Sacred Art.

106

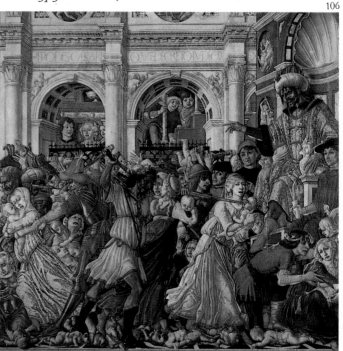

rational construction of space. For example, in the large altar-frontal of the *Coronation of the Virgin*, painted in about 1472 and formerly in the monastery of Monteoliveto, now in the Pinacoteca (no. 440), and perhaps the work in which he shows most of his talent as a painter, the composition is basically on the same plane, giving rise to a spectacular cascade of multi-coloured, sharply defined forms, while his Madonnas are marked by a gentle, dreamlike beauty that goes right back to the Gothic.

In about 1469-70 Martini formed a partnership with **Neroccio di Bartolomeo Landi**, a partnership that came to an end in 1475. But whereas after that date Francesco di Giorgio Martini almost entirely gave up painting to devote himself to an architectural career that earned him glory in many cities in Italy, where he left masterpieces of sacred, civil and military architecture, Neroccio spent virtually the whole of his working life in Siena, where he was born in 1447 and died in November 1500. Vecchietta's legacy to Neroccio was a taste for delicate transparent colours, which after the rather muted tonalities of the artist's earliest works gradually acquired increasing strength and vivacity until it reached the tawny flesh-tint and the glowing symphony of dark sapphires, vermillion and gold of

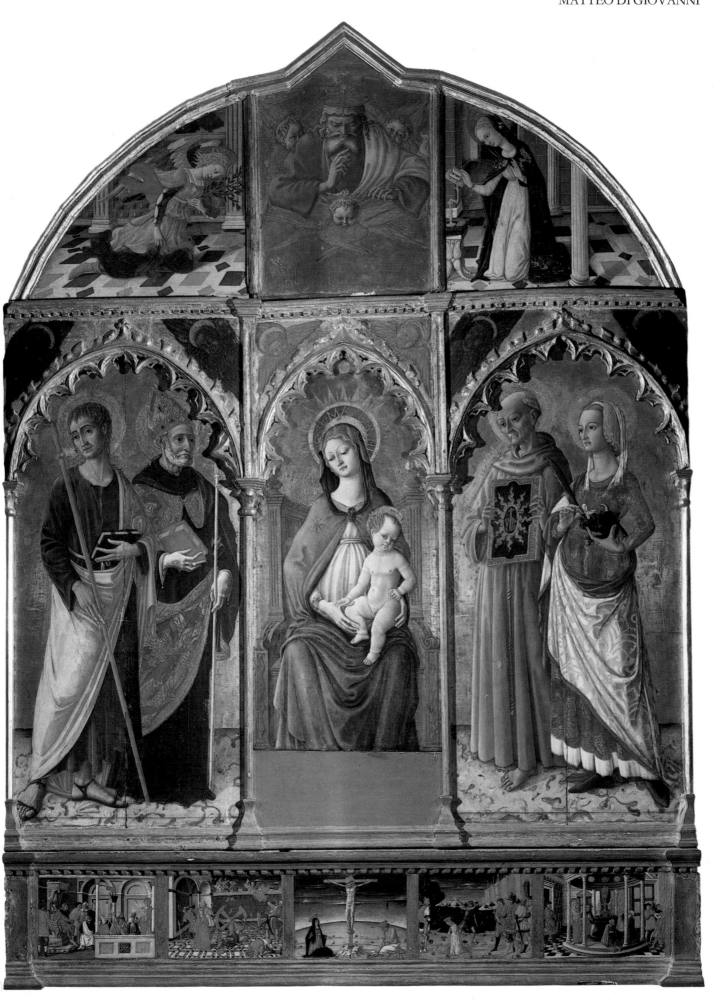

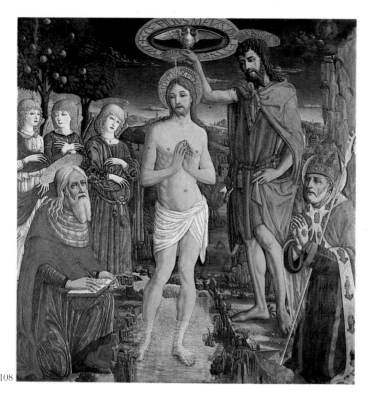

108

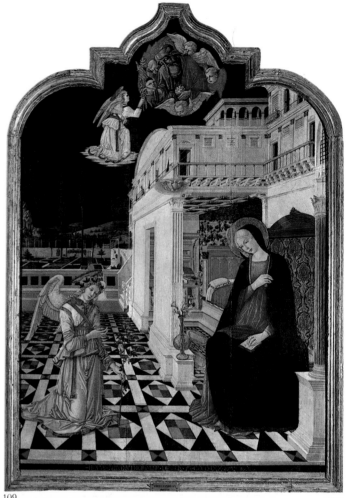

109

110

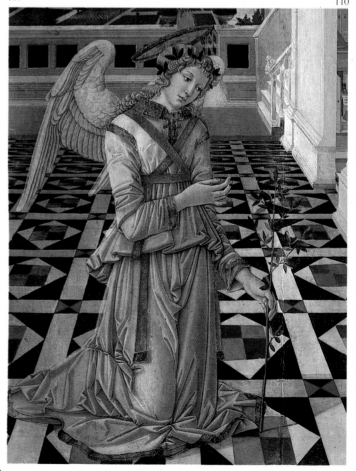

his last compositions. But the outstanding feature of his style is his highly musical sense of line, reminding us of Simone Martini, but by some miracle transformed and brought up to date by his intimate knowledge of the values, and even more of the intellectual atmosphere, of the Renaissance. The most perfect expressions of this unique meeting between the old Sienese Gothic tradition and the new spirit of humanism, with particular reference to the art of Donatello, are the many *Madonnas* with their elongated features, their heads gently inclined to one side, the penetrating look in eyes half-glimpsed under modestly lowered eyelids, and their finely tapering hands. Remarkable, if not very numerous, are his sculptures, justly renowned among which is the lovely wooden carving of *St. Catherine* in the church of Fontebranda in Siena.

A Sienese by adoption was **Matteo di Giovanni**, who was born in Borgo San Sepolcro in about 1430 but lived in Siena nearly all the time from about 1452 on. In that year, in fact, he went into partnership with an obscure painter called Giovanni di Pietro. In his earliest works (an altarpiece dated 1460 in the Cathedral Museum in Siena, a polyptych formerly in Sant'Agostino and now in the Museum at Asciano, and others) he revealed a basically Umbrian or Central Italian artistic background on which he grafted Sienese features derived from Vecchietta and Domenico di Bartolo. By 1461-63 he must have been already well thought of, since along with a group of much older painters – Sano di Pietro, Giovanni di Paolo and Vecchietta himself – he was invited to paint two altar-frontals for the Cathedral of Pienza. The *Flagellation of Christ* in the lunette of one of them, apart from other things, shows how soon this painter absorbed the lesson of Antonio del Pollaiolo.

Later on we see an increasing debt to elements of Florentine art (especially the sculptural qualities of Donatello), as well as the art of Umbria and the Paduan school, the latter reaching him by way of the miniatures of Liberale da Verona and Girolamo da Cremona, who had decorated a series of magnificent choir-books for the Cathedral of Siena. But this ability to absorb other cultures did not become mere eclecticism, because this artist's temperament, sensitive, humble and inclined to mysticism, made him interpret them always in terms of the Sienese tradition, closed to the true spirit of the Renaissance. Famous for his *Madonnas* withdrawn into a sort of gentle melancholy, Matteo several times, and with pungent realism, dealt with the tragic theme of the *Slaughter of the Innocents*, thus showing that his imagination was

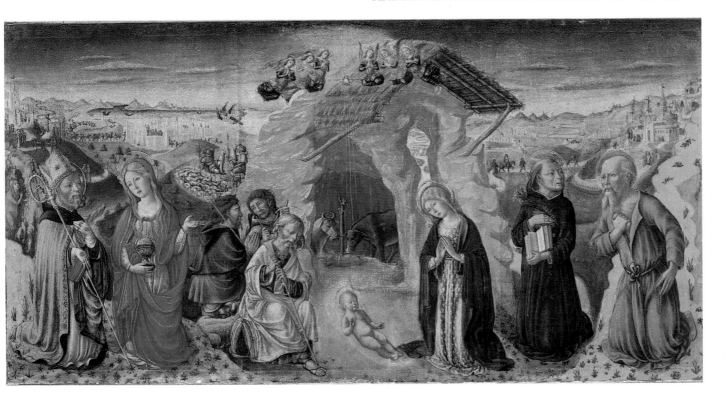

**Guidoccio Cozzarelli**
108. *Baptism of Christ*. Sinalunga, San Bernardino.

**Benvenuto di Giovanni**
109. *Annunciation*. Sinalunga, San Bernardino.
110. *Annunciation, detail.*

**Andrea di Niccolò**
111. *Nativity*. Pinacoteca.

**Girolamo di Benvenuto**
112. *Birth of the Virgin, detail*. Pinacoteca.

equally attracted by the extreme of tenderness and by the most violent cruelty.

A close disciple of his was **Guidoccio Cozzarelli** (1450-c.1517), who was often somewhat inert as an artist, but an exquisite miniaturist. As a painter he left us a fine *Baptism of Christ* in the church of San Bernardino at Sinalunga. The same church has the masterpiece of **Benvenuto di Giovanni del Guasta** (1436-1518), an altarpiece dated 1470 and showing the *Annunciation*, in which the Madonna has a gentle air worthy of the very best of Neroccio, while the luminous and beautifully detailed architectural features and the enchanting landscape in the background create an atmosphere of fairy-tale loveliness. This painting has little of those sharp linear qualities and forced three-dimensionality that characterize the style of this painter to such an extent, and that become positively wooden in the work of his son **Girolamo di Benvenuto** (1470-1524). Girolamo's large altarpieces are disjointed from a compositional point of view, but rich in airy backgrounds showing landscapes dotted with fantastic buildings, and on the whole better than these are a number of small panels showing the *Adoration of the Child*, executed with loving care and restraint.

Among the lesser painters of the end of the 15th and beginning of the 16th centuries are **Andrea di Niccolò** (documented from 1440 to 1514), who worked for a series of humble confraternities, local churches and poor monasteries, **Pietro di Domenico** (1457-1506), who evidently felt the impact of Signorelli and Perugino, **Bernardino Fungai** (1460-after 1513), who was also strongly influenced in his later period by Perugino and Pintoricchio, and was probably the teacher of **Giacomo Pacchiarotti** (1470-after 1539), who in spite of the eclecticism of his artistic education (as well as by Neroccio and Francesco di Giorgio he was influenced by Girolamo da Cremona and late 15th-century Florentine painters such as Filippino Lippi and Ghirlandaio) was an artist of considerable personality, with a delicate and tender style and fine sense of proportion in his composition. Maybe also a pupil of Fungai was **Girolamo del Pacchia** (1477-after 1533), who may have died at Fontainebleau. He was evidently influenced by the Umbrian school, but also by Raphael, Fra Bartolomeo and Andrea del Sarto, but though his paintings were done with all the diligent clarity of drawing characteristic of the 15th-century tradition, he did not achieve that unity of composition that was typical of the new century.

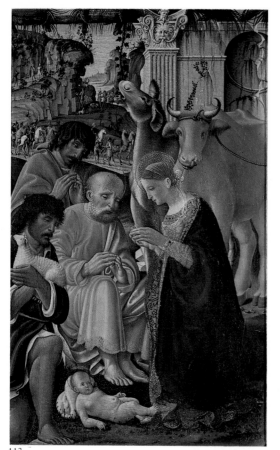

113

114

115

**Pietro di Domenico**
113. *Adoration of the Shepherds*.
Pinacoteca.

**Girolamo del Pacchia**
114. *Sacred Allegory*. Chigi Saracini
Collection.

**Giacomo Pacchiarotti**
115. *Visitation*. Pinacoteca.

# The 16th and 17th Centuries

Although Siena in the early 16th century had a fairly large body of working painters, the independence and originality of its own local tradition was waning and none of these painters was in greatness of authority in any way equal, I will not say to the masters of the first half of the 14th century, but even to the artists active in the middle of the 15th. The result was that works of art were increasingly often commissioned from outside. In 1498 Signorelli painted a polyptych for the church of Sant'Agostino, while contracts were drawn up in 1502 with Perugino, for a large altar-frontal for Sant'Agostino, and with Pintoricchio for the decoration of the Piccolomini Library.

Their presence and work in Siena, where Pintoricchio lived for a long time, dying there in 1513, was not without its effect on local painters. But it was a Piedmontese who first gave a decisive twist to the whole painting scene in Siena. **Giovanni Antonio Bazzi**, known as **Sodoma**, had come in the early 16th century to Siena from Vercelli, where he was born in 1477. For seven years he had been a pupil of Martino Spanzotti da Casale, and thereafter had probably spent some time in Milan, in contact with members of Leonardo's circle. By March 1502 he had already completed one of his masterpieces, the truly grand **Deposition** painted for the church of San Francesco (now in the Pinacoteca, n. 413), in which the plainly Piedmontese and Lombard features are united with a profound, but by no means servile, acquaintance with the art of Perugino. In 1503 and 1504 he frescoed the refectory of the monastery of Sant'Anna in Camprena, near Pienza, and between 1505 and 1508 did the twenty-six "stories" he added to the cycle of the *Life of St. Benedict* begun by Signorelli in the Great Cloister of the Abbey of Monteoliveto Maggiore, in which the detailed realism of the late 15th century in Northern Italy is further developed by means of forms and a breadth of space that is already fully in the 16th-century manner.

At the end of 1508 the artist was in Rome, where he began to paint the ceiling of the "Stanza della Segnatura" in the Vatican. This work was interrupted and later completed by Raphael, who respected Sodoma's original intentions. He went back to Rome in 1516-18 to fresco the wedding chamber of the banker Agostino Chigi in Villa Farnesina, a work that includes the *Wedding of Alexander and Roxane*, with its wonderful composition, soft light and shade that shows how perfectly he had already absorbed the lessons of Leonardo, and idealized graçefulness of the figures, in which we see hints of Raphael's taste for antiquity. For these qualities this painting is considered his masterpiece, and indeed one of the summits of 16th-century art.

But Siena was by now his adopted home, and with the exception of a few brief forays to Piombino, Florence, Lucca, Volterra and Pisa, he remained there and worked constantly, achieving a position of absolute pre-eminence over all other artists. Of his vast production we should at least mention the frescoes in the Oratory of San Bernardino (1518) and those in the chapel of Santa Caterina in the church of San Domenico (1526) with their famous if somewhat melodramatic scenes of the *Fainting* and *Ecstasy* of St. Catherine, and the *Execution of Niccolò di Tuldo*, the frescoes in the Cappella degli Spagnoli in Santo Spirito (1529-30), *Saints Ansano and Vittore* in the Palazzo Pubblico (1529-30), and the *Christ at the Column* (1515), detached from the wall in the monastery of San Francesco and now in the Pinacoteca (no. 352), a painting which reminds us strongly of Leonardo's manner.

Between 1525 and 1531 he painted the banner representing the *Martyrdom of St. Sebastian* for the Company called by the name of that saint, which in 1786 was forced to sell it for two hundred *zecchini* to the Grand Duke of Tuscany, so that it is now in the Gallery of the Pitti Palace. For centuries it was the object of fanatical admiration, but almost equal praise was bestowed on the lovely panel showing the *Holy Family and St. Leonard* (c. 1533) formerly in the Cathedral and now in the Palazzo Pubblico and the great altar-frontal with the *Adoration of the Magi* (before 1533) in Sant'Agostino. Also much admired were three altar-frontals done in Pisa between 1539 and 1543, after which the standard of Sodoma's painting began to fall off until his death in Siena on February 15th, 1549. In spite of his bizarre temperament and scandalous nickname, the artist lived an irreproachable life, and was knighted by Leo X; he had a number of pupils amongst whom we should mention **Bartolomeo Neroni**, known as **Il Riccio** (c. 1505-1571), who was also a fine architect.

A little younger than Sodoma was **Domenico di Jacopo di Pace**, who assumed his patron's name of **Beccafumi** (1486-1551) and was the other outstanding figure in 16th-century Sienese art. In 1510 he went to Rome to study Michelangelo and Raphael, whose forms and structures were freely transformed by him into an idiom characterized by the disintegration of volumes seen in strong light, and their recreation largely by means of highly enhanced colours with dazzling flashes, that enabled him to overcome the typically Florentine formalism of the time with his vivid contrasts of light and shade. He went back to Rome in about 1519, when Raphael's tapestries were on show in the Sistine Chapel, and then again in 1541-42, making drawings and studies of Michelangelo's *Last Judgment*, which had only recently been unveiled.

But, except for a few panels painted in 1537-38 for the Cathedral in Pisa, he worked almost exclusively for Siena, with an untiring series of frescoes, altarpieces and minor paintings, and among other things attending for nearly thirty years (1517-46) to the embellishment of the floor in the Cathedral, in which he radically changed the whole tradition of the use of marble in such a way as to achieve chiaroscuro effects worthy of painting.

His main works in fresco were the ceilings of a hall in the Palazzo Agostini (later Bindi-Sergardi, c. 1525) and of the "Sala del Concistoro" in the Palazzo Pubblico (1529-35), in which mythical events and examples of virtue from Roman history are presented as modern fables. He was not altogether uninfluenced by his rival Sodoma, but while the latter worked essentially within the sphere of 16th-century Classicism, Beccafumi – along with Rosso Fiorentino, Pontormo and Bronzino, and indeed somewhat in advance of them – was the creator of the Mannerist movement that was later to spread throughout Europe.

The extraordinary development of his style can be traced in a series of impressive altar-frontals, from the *Stigmata of St. Catherine* in the Pinacoteca (no. 420), to the truly stupendous *Annunciation* for the church of San Martino at Sarteano (1546). But we should also note that in the last years of his life, between 1548 and 1551, he modelled and cast eight wonderful angels bearing candlesticks in bronze for the Cathedral of Siena. With their intense and vibrant sense of light that sums up the whole of his vast production as a painter, they bear witness to the fact the Beccafumi was also the greatest Sienese sculptor of the 16th century.

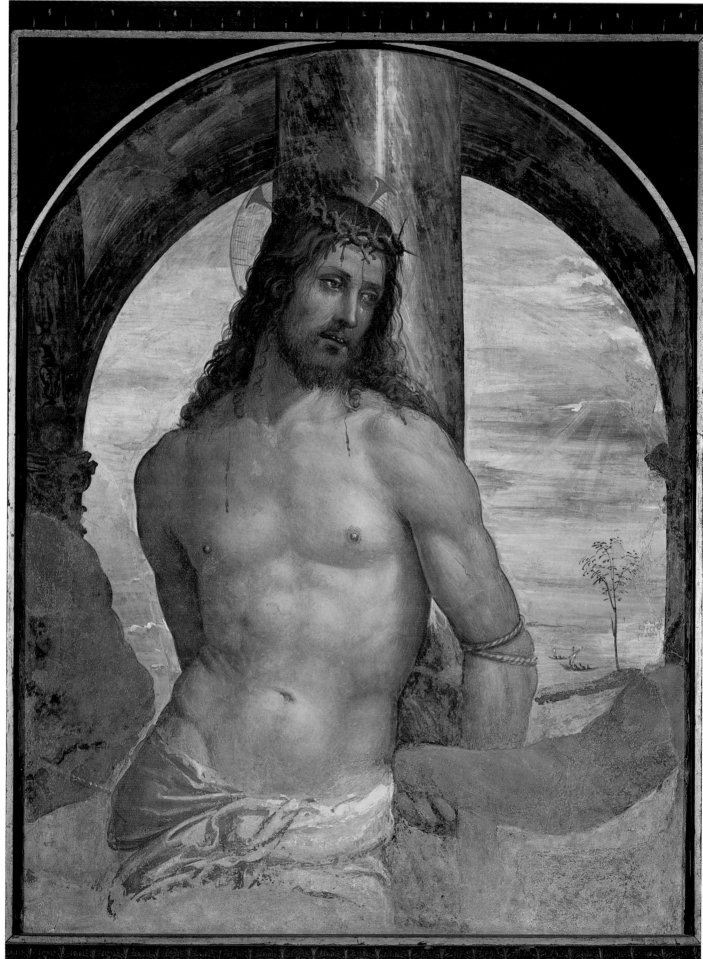

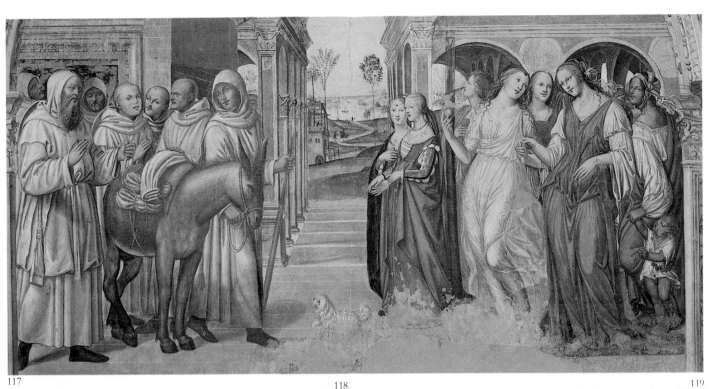

117        118        119

**Sodoma**

116. *Christ at the Column.* Pinacoteca.
117. *Stories from the life of St. Benedict, detail, the prostitutes are invited to the monastery.* Abbey of Monteoliveto Maggiore.
118. *Madonna and Child.* Palazzo Pubblico.
119. *The Fainting of St. Catherine.* San Domenico.

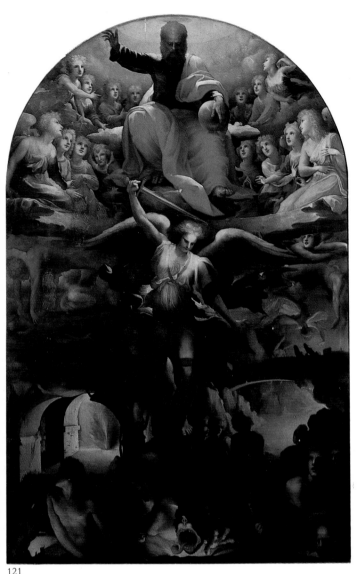

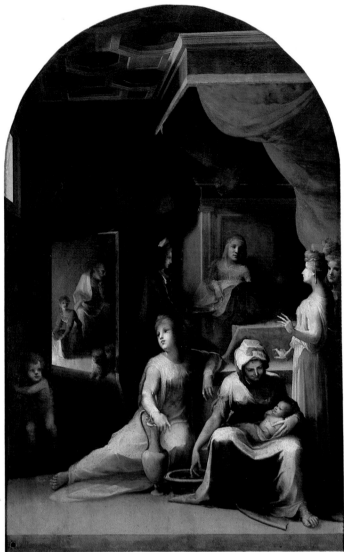

121

122

123

**Domenico Beccafumi**

120. *St. Catherine Receives the Stigmata.* Pinacoteca.
121. *The Archangel Michael.* Santa Maria del Carmine.
122. *Nativity of the Virgin.* Pinacoteca.
123. *The Continence of Scipio, detail.* Palazzo Bindi Sergardi.

124

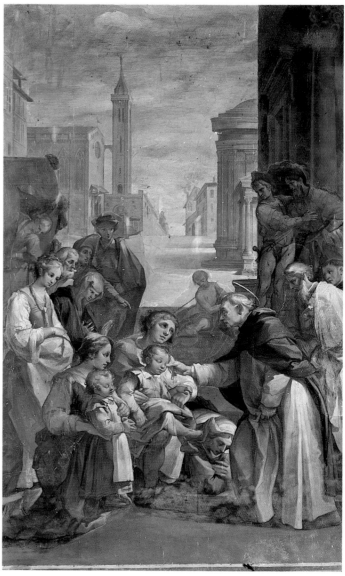

Of lesser importance, at least in comparison to his outstanding work as an architect, was the painting of **Baldassarre Peruzzi** (1481-1536), who was influenced chiefly by Pintoricchio and Sodoma and worked mostly in Rome. In the fresco of *Augustus and the Sibyl* in the church of Fontegiusta, painted when the artist took refuge in Siena because of the Sack of Rome in 1527, he even shows a tendency towards the art of Beccafumi.

The fall of the Republic of Siena in 1555 coincided with a period of comparative artistic inertia. But in the last third of the 16th century painting picked up again, creating what Abbot Lanzi called the "third period" of Sienese painting, largely based on Roman models but with certain echoes of the Venetian style. All the same, it cannot be compared with the great works of previous centuries, even though it produced some prominent personalities such as **Arcangelo Salimbeni** (died 1580), a follower of Il Riccio and the adopted father and teacher of **Francesco Vanni**, who was influenced by Barocci in his mature years and was the leading representative of the spirit of the Counter-Reformation on the Sienese painting scene. We might also mention his half-brother **Ventura Salimbeni** (1568-1613), who worked in Rome, Lucca, Pisa, Genoa and other cities, and was mainly notable as a painter of frescoes; **Alessandro Casolani** (1552-1606) and **Pietro Sorri** (1556-1621), both of whom in their best work were capable of the sort of wondrous colour that we associate with Veronese, and the less talented **Sebastiano Folli** (1568-1621) and **Raffaello Vanni** (1587-1673). **Rutilio Manetti** (1571-1639) was the major Sienese painter of the 17th century, growing up in the late-Mannerist school of Vanni and Salimbeni, and then going over to

the style of Caravaggio, of whom he was one of the most talented followers, even if there is little or no consistency in his vast output.

On much the same level as Manetti was **Bernardino Mei** (c. 1615-1676), in whose work we see echoes of Mattia Preti, who had carried out some commissions in Siena, of Guido Reni, whose lovely *Crucifixion* is in the church of San Martino, of Maratta and Sacchi. Meanwhile **Francesco Rustici**, know as **Rustichino** (c. 1580-1626) asserted himself by means of his intense and personal use of the light-effects associated with Honthorst, especially in the last works that he did for the Grand Duke of Tuscany. Very famous at his time was **Astolfo Petrazzi** (1597-1665), the founder of a school or Academy in Siena, and now almost entirely forgotten. Another little-known painter worth mentioning is **Niccolò Tornioli**. Active in Rome in the second quarter of the 17th century, he was a vigorous follower of Manetti who also came under the influence of Rustichino. Also much praised at his time was **Giuseppe Nicola Nasini** (1657-1736), who belonged to a family of painters from Casteldelpiano sull'Amiata, whose style was based on the work of Pietro da Cortona and Baciccio. He had a large number of pupils in Siena, none of whom – unless scholars come up with some surprise, as 18th-century Sienese painting is still an untilled field – seems to have risen above the level of dignified mediocrity.

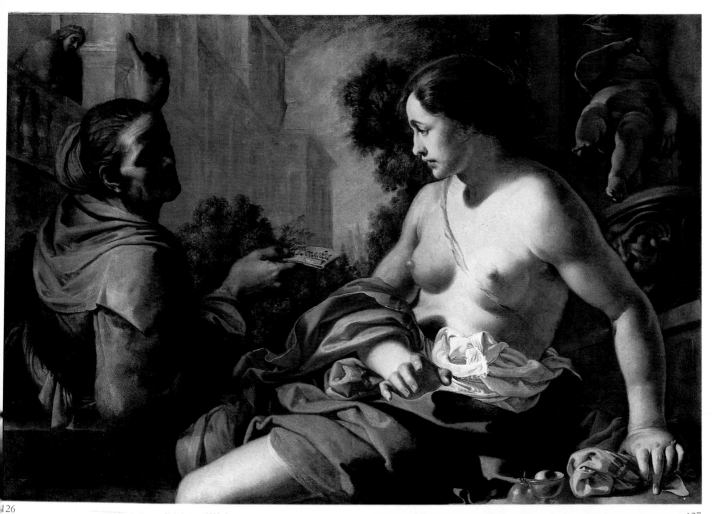

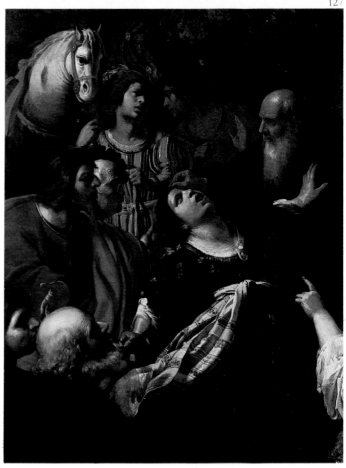

**aldassarre Peruzzi**
24. *Augustus and the Sibyl.* Church of Fontegiusta.

**entura Salimbeni**
25. *A Miracle performed by St. Giacinto.* Santo Spirito.

**ernardino Mei**
26. *Bathsheba.* Chigi Saracini Collection.

**utilio Manetti**
27. *The Exorcism of the Possessed Woman, detail.* Basilica of San
Domenico.

# Bibliography

G. VASARI, *Le vite . . .*, Firenze 1568 (ed. Milanesi, Firenze 1878).
R. LANGTON DOUGLAS, *History of Siena*, vol. II, London 1902 (ed. ital. Siena 1926).
E. VON MEYENBURG, *Ambrogio Lorenzetti*, Zürich 1903.
B. BERENSON, *The Central Italian Painters of the Renaissance*, New York-London 1908.
E. JACOBSEN, *Das Quattrocento in Siena*, Strassburg 1908.
E. JACOBSEN, *Sodoma und das Cinquecento in Siena*, Strassburg 1910.
F. HARTLAUB, *Matteo da Siena und seine Zeit*, Strassburg 1910.
C.H. WEIGELT, *Duccio di Buoninsegna*, Leipzig 1911.
B. BERENSON, *Essays in the Study of Sienese Painting*, New York 1918.
R. VAN MARLE, *Simone Martini et les peintres de son école*, Strasbourg 1920.
E. GAILLARD, *Sano di Pietro*, Chamb...
L. GIELLY, *Les Primitifs siennois*, Pa...
P. TOESCA, *Storia dell'Arte italiana:*...
E. CECCHI, *Trecentisti senesi*, Roma...
C.H. WEIGELT, *Die sienesische M...* München 1930 (ed. ital. Bologna 1...
E. CECCHI, *Pietro Lorenzetti*, Milan...
C. BRANDI, *Rutilio Manetti*, Siena 1...
G.H. EDGELL, *A History of Sienese ...*
C. BRANDI, *La R. Pinacoteca di Siena ...*
G. SINIBALDI, *I Lorenzetti*, Siena 19...
J. POPE-HENNESSY, *Giovanni di Pao...*
G. VIGNI, *Lorenzo di Pietro detto il V...*
J. POPE-HENNESSY, *Sassetta*, Londo...
A.S. WELLER, *Francesco di Giorgio M...*
C. BRANDI, *Giovanni di Paolo*, Firen...
J. POPE-HENNESSY, *Sienese Quattroc...*
C. BRANDI, *Quattrocentisti senesi*, Mi...
C. BRANDI, *Duccio*, Firenze 1951.
M. MEISS, *Painting in Florence and S...* ton 1951 (ed. ital. Torino 1982).
P. TOESCA, *Storia dell'Arte italiana:* ...

E. SANDBERG VAVALÀ, *Sienese Studies*, Firenze 1953.
E. CARLI, *La pittura senese*, Milano 1955.
E. PACCAGNINI, *Simone Martini*, Milano 1955.
E. CARLI, *Sassetta e il « Maestro dell'Osservanza »*, Milano 1957.
G. ROWLEY, *Ambrogio Lorenzetti*, Princeton 1958.
G. COOR, *Neroccio de' Landi*, Princeton 1961.
J. STUBBLEBINE, *Guido da Siena*, Princeton 1964.
S. SYMEONIDES, *Taddeo di Bartolo*, Siena 1965.
E. BORSOOK, *Ambrogio Lorenzetti*, Firenze 1966.
R. OERTEL, *Die Frühzeit der italienischen Malerei*, Stuttgart 1966.
D. SANMINIATELLI, *Domenico Beccafumi*, Milano 1967.
H.W. VAN OS, *Marias Demut und Verherrlichung in der sienesischen Malerei 1300-1450*, s'Gravenhage 1969.
G. CONTINI-M.C. GOZZOLI, *L'opera completa di Simone Martini*, ...ano 1971.
...SCHI, *L'opera completa di Duccio*, Milano...
... d the Sacristy of the Siena Hospital Church,
...SCHI, *L'opera completa del Beccafumi*,
...zionale di Siena, Genova 1977-1978.
...talogo della mostra), Firenze 1978.
...a senese 1330-1370*, Firenze 1979.
...Genova 1979.
...*Buoninsegna and his School*, Princeton
...*Art and the Medieval Workshop*, London
...1979.
...*tto i Medici* (Catalogo della mostra),
...*n its Origin to the Fifteenth Century*, New
...*l Trecento*, Milano 1981.